D1269367

STEPHEN KASNER

WORKS: 1993-2006

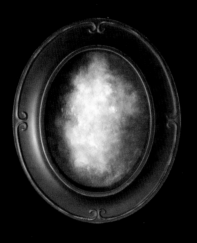

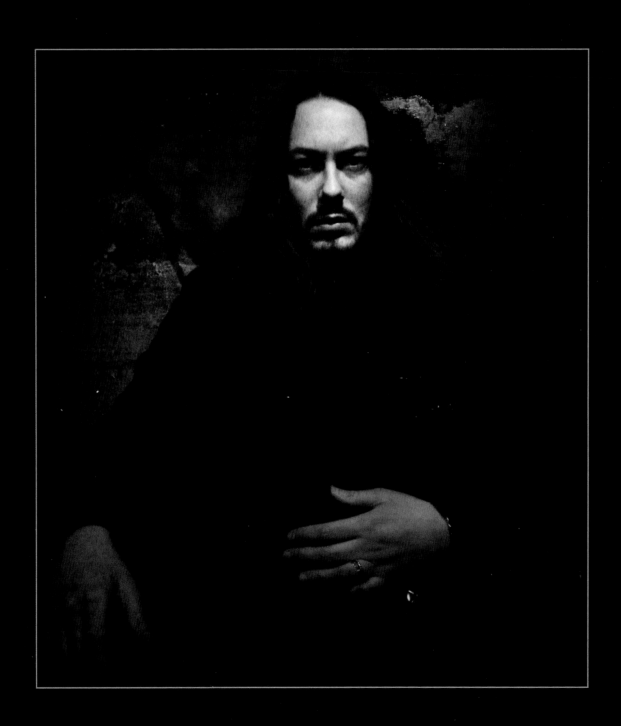

STEPHEN KASNER

WORKS: 1993-2006

SCAPEGOAT PUBLISHING

❧ SCAPEGOAT PUBLISHING
Baltimore, MD
ScapegoatPublishing.com

First Edition
5 4 3 2 1

⊹ Master numbered edition (50 copies) with slipcase, ltd. ed.
Giclée print, 10″ record in gold ink silk-screened sleeve
and 10x10″ original painting on aluminum.
⊹ Slipcased hardback numbered edition (200 copies) with ltd. ed.
Giclée print and 10″ record in silver ink silk-screened sleeve.
⊹ Hardback edition ISBN 0-09764035-5-2
⊹ Paperback edition ISBN 0-09764035-6-0

A CD of the music from the numbered editions is available on Reptilian Records.
Copy editing - Rebecca Kasner
Layout and design - Kevin I. Slaughter and Stephen Kasner

for Madeleine

foreword by Dwid Van Hellion

When Stephen asked me to write a forward to his first book I was incredibly honored that he would think to include me in something so important, something that will define his work up until this moment in time. After several drafts and attempts at writing this, I found that it was very difficult for me to put into mere words the feelings I have for my friendship with Steve, and to clearly express my affinity for his masterful paintings and artwork.

Stephen Kasner has a unique ability to draw back the curtains and reveal a glimpse into a world where beauty and nightmare exist in perfect and glorious harmony. Beneath a thick veil of consciousness lies a world that only exists inside the imaginative mind of Stephen Kasner. His images show more than a visual representation into his creative genius, they genuinely convey emotion of that captured moment of time. When I look at one of Stephen's paintings I find myself drawn inside and immersed within the four walls of the canvas. I can feel the breeze of a storm

on its way gently whisper across my face, the faint cry of ravens calling out in the distance as the scent of flowers mixed with brimstone overwhelm my senses. Silver scratched landscapes that reveal a passage into the soul of a passionately tormented masterpiece. Few artists posses the ability to open the door to the senses, to really bring you into the moment and allow you to explore every shattered stone, furrowed feather, and silver cloud.

や

I came to meet Stephen by a chance visit to a Cleveland art gallery one afternoon with my good friend, Nick "Fiction" Brewer. Circumstance put me in a position where I had a deadline and was in need of the perfect artwork to be employed on an upcoming album I was working on. As luck would have it, when Nick and I entered the gallery, my search for perfection was over.

I was immediately awestruck by his paintings, they were so original and refreshing,

yet at the same time I could sense many of my favorite artists being a fundamental but subliminal influence in the world of Stephen Kasner. The curator passed along Stephen's telephone number and after one call, Stephen and I became great friends. It was as if we had known each other for a lifetime, we shared so many similar passions for music, art, film, philosophy, & even similar friends. Nearly every topic we would breach, we seemed to share an identical match of interest and influence.

After explaining my wish to license some of his artwork for my album, Stephen asked if he might have a listen to the new songs. A week after I dropped off the cd, my telephone rang, and as I answered an excited Stephen was on the other end of the line telling me that he had decided to create original pieces for my album rather than offering an existing painting. It was so flattering that a craftsman of his caliber would be willing to create something inspired by my music that I, of course, immediately drove over to his

studio, anxious to view his creations. Words cannot describe how perfectly he was able to convey the music into his world of images; I was speechless. To this day whenever I look at that album cover, I am reminded of our first meeting and how our friendship blossomed - and continues to thrive to this day.

If you are reading this, then you own this book and shall soon understand how Stephen Kasner's paintings can mesmerize and inspire an entirely different part of your nature that you may not have known existed beneath the surface of your dreams. Welcome.

Dwid Van Hellion
August 21, 2006

All art is the chronicle of a haunting, in the same way that every narrative is at least in part a ghost story: Through sudden surprise or gradual recognition we begin to remember something of the origins of our strange lives, bounded and dwarfed by the towers of an eternity from which we are only briefly exiled. The whole broad sea of time is our true home, the deeps from which we have lately made our way onto a strand of present moments.

There is a strain in contemporary American art that seems haunted as much by the future as by the past – but haunting knows no tense, and it's more that history has changed its flow; we're all at a bend in the river. Floating on the water are petals of flowers with an unfamiliar scent, different from any we know; blazoned in the sky are marvels glimpsed in moments of elation or despair. Maybe those who believe the earth is hollow, that the sky is a shadow on a bowl, know something that reason cannot.

Stephen Kasner's paintings are like skeleton keys to a room beyond that sky,

where the children of the beginning wait for the real to come home again. A visual poet, he uncovers, rather than depicts, eternal figures stamped in the mind before it became flesh, engraved like a song in the howling grooves of each human fate. Kasner recalls, and helps us to recall, what it is to be enchanted, cursed, paralyzed, enthralled, what it is to be a child and discern the cracks and wounds in the world.

One underlying use for narrative as a web-like logical structure is to bind and sooth those wounds of everyday experience. But I would like to talk about the ways that Kasner's art aims to be both the gauze and the wound, the comment and the thing itself. His imagery persists beyond process, so that the various methods and materials of art making become less like tools of depiction and more like the prodding of sharp instruments. They search for a kind of pain that lies at the edge of pleasure and is the living skin, the nerve of a reality that underlies all searching, journeying, storytelling. They find this breathing,

stitching, reality suspended still in a torn web of fairy tale and nightmare.

❧

Often Kasner shows us only the head of a nameless songbird, a dark, round, sleek shape, damp with the fog that surrounds it. Its beak tends to be curved, like a crescent moon. One ink drawing is titled *Study for Portrait or Self-Portrait* and reveals a being with this typical bird visage. It is seated facing the viewer's left, a gown with multiple scalloped edges billowing below the waist. A disembodied hand crawls up its shoulder and a nervous haze of overspray spreads through the space behind the figure, like smoke.

As in many of Kasner's paintings and drawings, there are curtains framing this snapshot-like study of sudden presence. We are privileged to attend a drama conducted by the night itself, in which we are instructed in the language of certain forces. They flicker, personified, fluttering like the flags of an

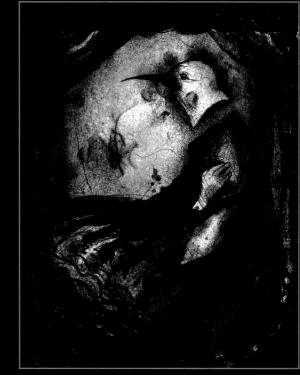

extinct army, shaking their severed limbs, half dissolved by starlight and damnation.

Kasner travels to remote areas of the mind. There are things he provides for himself and the viewer for these journeys into and out of the painted surface; though they are neither supplies nor companions, but are as much discovered as carried -- things found, persons searched for, testimony refined with each successful journey:

There are those birds, for instance, sleek and black as the tide; sometimes just one appears, as a familiar; at other times a flock swirls around an enigmatic light.

There is a vessel, a vortex spinning the stars like a vase spewing flowers; or like the pox of a beautiful disease.

And the flowers themselves — not flowers as we know them but beautiful abrasions rubbed into the inks of time, proffered by shadow.

The Man appears at certain key moments, whether priest or devil, goblin or a face to the great, devouring Vortex : he serves as an emblem of all presence.

And occasionally there is a glimpse of the Woman, a mutable shape caught between lights, the penumbra of desire.

の

I've walked in cemeteries all my life, mindful of the dead waiting for the universal clock to wind down or break, just a few feet underground. Planted at intervals in the close-shorn grass, headstones protrude in long rows or orderly family groups. Everywhere I step across the shards of biological machines that once were self-contained worlds; that were myself.

Near the Cleveland Institute of Art where Kasner studied in the early 1990's, the curving roads and footpaths of Lakeview Cemetery gradually wind up the gentle slope of a great escarpment, high above the level plain of the city. Designed during the last half of the nineteenth century, Lakeview is an idyllic garden for the dead, a park with enormous tulip trees rising from patches of ivy, with hoary wild plum here and there and sometimes patches of bare earth in dry seasons, where groundskeepers left a pile of oak leaves too long past autumn. If on a sunny day a visitor's attention wanders, it's possible to become quickly, completely lost. Paths curl around obelisks like a game of snakes and ladders and one mausoleum looks much like another.

Those little temples, as abstract in their way as a child's picture of a house, fascinate me. A product of slightly crazed human industry as ancient in origin as our oldest stories and tombs, they're real places for transcendence to lay down its immaterial head. As I stroll I wonder what it would be like to live in one, or at least to be lost for a day in the maze of paths and little hills and ranks of stone, and find an open mausoleum, or break open one of the century-old locks and let myself in; I would rest on the bench-like marble slabs covering the dead. Finally I walk up to one and peer in, put my nose against

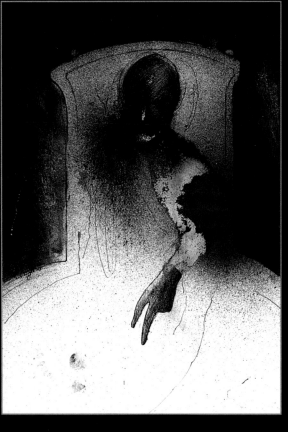

the grating that protects the glass and catch my breath as I dare another face to look back at me.

Kasner's paintings can be like that. Something lurks in the far corner of a dark room, obscured by reflections and the haze of our own breath. Or are these the mediums that animate it? The artist provides us with layers to look through, dimensions to sift so that we have a better chance of seeing what he means us to see. Even in those works where the figurative elements are most obscure, the underlying source of their unusual power is always an intimation of that *presence*, that immanence of power and personality. This is not a matter of depicting anybody in particular, since Kasner is not telling any particular story. It's close to the truth to say he is *being* this story, if anything, and his paintings are pockets in the garment of everyday life, hidden among the folds of normal events, where heightened perceptions can be kept safe from change and loss. Immanence in such paintings is a matter of

prolonged process, of alchemical struggle and incremental shifts accomplished through a practiced activation of darkness. Perhaps the visible symbols are something like an address, to speed these messages deep into the older mind where the truest dreams and best monsters stir.

Walking again at twilight one evening, in the wooded area that borders a man-made lake not far from Lakeview Cemetery, the path cuts though a stand of mixed hardwood trees, bending into the green a few dozen yards ahead. I turn and look behind me, almost startled though nothing has happened, feeling that anything could appear from just beyond the verge of those slight curves that block my vision. Suspense, or at least tense anticipation, shadows the acts of stopping, of turning, or of moving on. As T. S. Eliot put it, "Here you can neither stand, or lie, nor sit."

Kasner's paintings are also like *that*. They

wait, having situated themselves between *now* and *then* as carefully as a hunter in a blind; unless it may be that they are the hunted. Toward the end of the nineteenth century Sigmund Freud wrote in his *Theory of Dreams* that the artist is a man who has turned away from reality because he can't make peace with it, but that he finds his way back, molding fantasies into new realities. This is a tale (or part of a tale) older than civilization. Not only artists, but every seeker journeys into the waters of being in search of a cure for death, a balm for our sense that "reality" is insufficient and limits our native infinity unpardonably. Kasner goes to his canvas like a man going down to the ocean for a midnight swim, as all dreamers do, seeking many things, identity and freedom among them.

There are only a relative handful of important artists who have explored midnight in just this way over the past two or three hundred

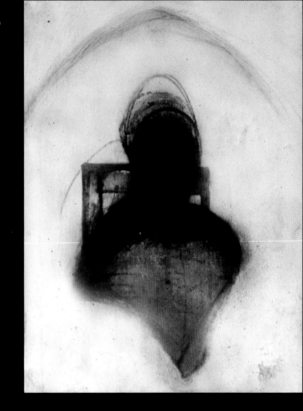

years, but the lineage is nevertheless complex and distinguished. In literature a surprising number have been Americans: Poe and Hawthorne, of course, but also popular contemporary novelists of real genius like Stephen King and Anne Rice. Among painters there was the incomparable Albert Pinkham Ryder, and at present Ross Bleckner. But it is necessary to return to *fin de siecle* France to find a clear context for Kasner's imagery. The symbolist Odilon Redon's orb-studded etchings, where eyeballs and faces float in the nether skies of a visionary world, is the most obvious precursor to Kasner's highly atmospheric, uncanny approach. Redon's work was fully described in the pages of J. K. Huysman's novel *A Rebours*, usually translated as *Against Nature*, which in turn inspired Oscar Wilde's *The Picture of Dorian Gray*, and later British novels about spiritual darkness. Writing from 1930 into the 1960's, Charles Williams and others of the so-called 'Inklings" group, which included C. S. Lewis and J. R. R. Tolkien, described a world at risk,

threatened by Satanic powers. In fact, from Bram Stoker to Dan Brown, such subjects have loomed large in every medium from film to coffee table literature.

But despite all these works and nearly a century of surrealist efforts that also delve into realms of fantasy and the illogic of dream, Kasner's precursors and influences are nearly identical with Redon's: Goya and Fuselli, Bosch and of course William Blake all come to mind. One more might be mentioned, whose paintings also hung in the exotic fictional home of Huysman's morbidly effete protagonist le Duc Jean des Esseintes (a character inspired by Poe's Roderick Usher): the noted symbolist painter Gustave Moreau, whose jewel-like canvases depicting visionary worlds populated by sphinxes and hermaphrodites seem to exude an aroma of myrrh. Other contemporaries of Redon like the German Franz Von Stuck also explore related themes.

But it is the more recent student of anguish and transformation, Francis Bacon,

who, after Redon, seems closest to Kasner. As one of the select group of mid-twentieth century artists (Nathan Oliveira, Alberto Giacometti, Leon Golub, and to a lesser extent fellow "School of London" painters Frank Auerbach, Leon Kossuth, and Lucian Freud) who explored a similar idea of human presence, Bacon searched throughout his tormented life for the "ghost in the machine," in the 1949 phrase of his contemporary, the British philosopher Gilbert Ryle. And it was Bacon, far more than any painter of the human figure before or since, who insisted most cogently on the procedural nature of this search. In an interview with the art critic David Sylvester he remarked:

You know in my case all painting…is accident…It transforms itself by the actual paint. I use very large brushes, and in the way I work I don't in fact know very often what the paint will do, and it does many things which are very much better than I could make it do. Is that an accident?

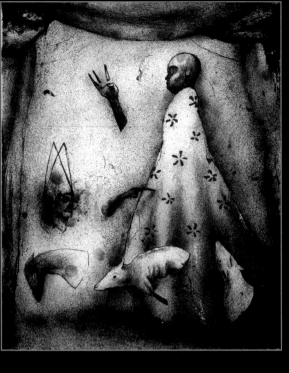

UNTITLED.
Ink on paper, 12 x 10″ 1994

Perhaps one could say it's not an accident, because it becomes a selective process which part of this accident one chooses to preserve. One is attempting, of course, to preserve the vitality of the accident and yet preserve a continuity…

What has never yet been analyzed is why this particular way of painting is more poignant than illustration. I suppose because it has a life completely of its own. It lives on its own, like the image one is trying to trap; it lives on its own…

Again and again in his interviews with Sylvester, Bacon talks about the near-impossibility of this kind of painting, stressing the crucial difference between that and "story-telling," distinguished by planning and deliberate depiction. In our conversations over the past thirteen years, Kasner also has often complained of the difficulty that this kind of work entails, and as an artist with similar ambitions I know what he means. Everything is a danger to the impossible disequilibrium

that such works attempt. As the painter tries to conjure an equivalence of real things from mute materials, sometimes a flicker of life seems to twitch in the pile of accumulated marks and splashes on paper or canvas, like a voice crying beneath rubble. The temptation is to dig faster, to push for more and more life, for louder cries – but often such redoubled efforts only ruin the piece. In many areas of life it is of critical importance to know when to stop, but in the case of such rude conjuring stopping can be the most important thing of all. Or at other times the painter is convinced that he has uncovered a truly vital image and throws down his tools too soon, only to become disillusioned and paint over the imposture in despair.

Every kind of art is at bottom a type of transposition, not unlike language and mathematics. Musical notes and lines on paper are much more like tracks, though, clues about living things left pressed in the earth or hanging in the air. Their basis is more physical then conceptual, and the message

they carry has more potential impact as body blow than brain teaser. That hasn't stopped several generations of ambitious artists and critics from drafting art as a sort of quarter back for philosophy, using its muscle to carry a variety of epistemological concepts down the field of discourse. Painting in particular may be better suited for other tasks, however. Certainly Kasner thinks so.

Consider, for instance, the shamanistic nature of much artistic practice, so evident in the kind of work he does. Incomparably more ancient than the European panting to which he is heir, is the place where Kasner goes when he paints, where the riddle is posed and the answers reside, mixed as always in pigment and charcoal. It is of great significance for Kasner and anyone who uses them, that those materials, scavenged from river banks and scooped from the fire pit, are of immemorial antiquity. Drawings made from almost the same substances persist in caves throughout Europe and Africa, so old that, like the Bradshaw paintings in Australia's Kimberly

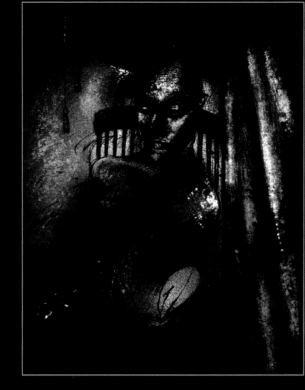

Region, they've fused with rock. For countless generations our ancestors sought guidance, inspiration, and deliverance from the realms of dream and night, and it is surely vain to suppose that we have changed in the few brief millennia that civilization records. This pictorial art that Kasner essays with every stroke and line and smear is among the oldest human cultural activities of which we have clear evidence, a part of *homo sapiens*, bred in the bone. What does it mean, after all, that we find those primordial paintings *beautiful?*

❧

I met Stephen Kasner in 1993, under circumstances that I think shed some light on his character both as a person and as an artist. It was the year of his graduation from the Cleveland Institute of Art and he had arranged to present a show of his own work at an unusual venue – and in most unusual company.

The place was called **The Idea Garage**, the brainchild of well known painter, sculptor and instructor at CIA, Ed Mieczkowski. Located off Euclid Avenue, and abutting the eastern boundary wall of Lakeview Cemetery, the gallery/garage was adjacent to Mieczkowski's studio. Over the past few seasons the barn-like interior had served as temporary home to several experimental student projects.

All of those paled, however, in comparison to Kasner's. For a period of many months the young artist had entered into an extraordinary correspondence with some of the most dangerous men in the world, exchanging letters with Ottis Toole, Henry Lee Lucas, Herbert William Mullin and "Night Stalker" Richard Ramirez, among others; he'd even spoken on the phone on many occasions with John Wayne Gacy, developing a cordial long distance relationship with the killer clown. The conversations continued long past the exhibition's run, all the way up to Gacy's execution in May, 1994.

All of these men had sent him their drawings and paintings from the depths of high security prisons, a selection of works in various media which Kasner duly exhibited late in the same year, alongside his own paintings and those of a fellow CIA graduate, Vaughn Bell in a show titled simply *Human*. It was the ultimate "outsider" show. As Kasner's press releases got around to the various media, a flurry of national interest in the project arose. No doubt Kasner had hoped for some of this attention, and enjoyed the sheer madness of it all as correspondents from ABC News and the Washington Post descended on the old garage with its cracked cement floor. Yet I'm certain these things aren't really what attracted Kasner to the venture.

To be Art with a capital A, lines need not only to be drawn, but crossed. Partly this sense of transgression, of sins committed or authorities defied, is a personal matter. Each of us has a set of interior boundaries that fence off the possible from the unthinkable, and it may be that artists have a particularly clear sense of such limits. In any case, at

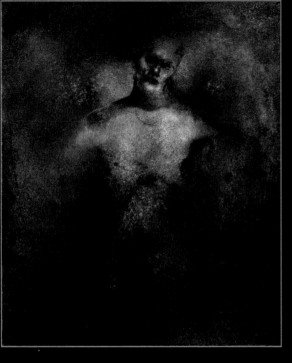

FIGURE IN STORM.
Mixed media on paper, 10 x 8" 2004

a time when art is rarely a serious force for political change, the avant-garde has long since turned inward. Outsider works challenge the trained practitioner to rephrase the basic questions of contemporary art. What, after all, is "Insider" art? In what way does the discourse of art schools and galleries earn its privilege? It's easy to dismiss the work of psychotics, especially newsworthy psychotics guilty of sickening crimes, dark celebrities adopted by their time as resident grotesques. It seems only sensible to regard such art as either motivated by a twisted desire for further notoriety, or simply as bad art. And no doubt it is both. But still, there is another point of view.

Transgressions, art crimes so to speak, are at the heart of what the best and most ambitious artists commit as they search for an effective method. From Prometheus to the latest aesthetic rebel in the Saatchi's pantheon of bad boys and girls, artists and critics have believed that a sufficiently bold, cunning, or offensive act may cheat the impoverished destiny that keeps us from the fire of truth.

A governing principle of modernity (and even the Romans had a notion of what was modern) is that new creative space must be cleared somehow, so that fresh perceptions can define coming generations; this is one of the great cultural necessities. But it's not easy – or at least, like any crime, not easy to get away with. The pitfalls are much the same for the artist and the novice thief or murderer. Clumsy attempts are quickly discovered and removed from the population. Successful transgressions are usually a matter of bringing something judged to be outside the sphere of fine arts discourse, dripping and hissing into the confines of gallery or museum. Hence Marcel Duchamp and his urinal, Damien Hirst and his embalmed animals. The initial shock value soon becomes an incurable wound. We may have bounced back from Hirst already, but the damage caused by Duchamp goes on. Every new generation since his 1917 tour de force has understood that anything can be art, and anything that is tacitly excluded from aesthetic discourse

must eventually be carried, kicking and screaming into the temple. The philosopher Michel Foucault of course grasped this central fact better than anyone: the excluded, the disenfranchised, the despised are the food of aesthetic and political progress alike.

Therefore, nobody belongs in a gallery context more than Charles Manson. Whether this is at all true in a broad sense, whether there is any innate visual or spiritual power in his drawings and paintings that merits appreciation (and many have considered Manson and others in Kasner's exhibit to be highly gifted individuals), is not really the point of this story. That it occurred to a young painter of darkness to bring the heart of darkness itself into the cradle of his own fledgling life in the arts, is. Kasner rarely refers to these events now, after more than a decade of further explorations in his own richly textured world of materials and portents. But the level of commitment that the show demonstrated continues to say much about the *extreme* nature of his work.

I use the word grotesque above to describe the serial killers' place in the American nightmare, and this points to yet another way to understand both that early exhibit and the archetypal dance of images in the whole of Kasner's painted world. *Grotteschi* were late classical statues of deformed beings, re-discovered during the Renaissance in the ruins they were made to decorate. They quickly became part of a philosophical conversation that continues to this day, about the nature of art and its function in different societies. As symbolist art flourished in the wake of earlier Romantic novels, poems, and lives, influenced by Blake and Coleridge, Hugh Walpole, Mary Shelley, E. T. A. Hoffman, Charles Maturin, and many others including Victor Hugo and the essayist and art critic John Ruskin, the role of distortion in the arts became ever larger and more indispensable. Such archetypal freaks as Frankenstein's monster (Mary Shelley's subtitle for *Frankenstein* was *A Modern Prometheus*) were conceived as a critique of human reason, and grotesques

in general have often been used as tools for deconstructing the role of the rational mind, spading over logical constructions in a dig for the buried treasures of the spirit. Even more than that, they are the ancient spirit of disruption and discontinuity itself at work, the trickster figures (like the native American Coyote) of shamanistic societies reminding us how shallow our understanding really is.

જી

Walking through the cemetery again, this time late in an evening in August, the tombs and trees fade into the darkness while the dirt path I've found seems to glow faintly, though there is no moon. As the visible retreats, sounds are magnified. The undulating high-pitched whine of thousands of cicadas grows louder. The lonesome, artificial scene fades into the night against the scream of the insects' demented music, and I am briefly marooned in a no-man's land, a transient island between the senses. Neither sight nor sound alone, the

coming night is an almost tangible figure kneaded from both, a golem. And again I think of the internal repetitions and deliberate rhythms of Kasner's art, of the way its recurring images and singular flourishes seem to me to rhyme, almost, and pace in circles like lines from obsessive, incantatory poems by Poe or Coleridge:

The night is chilly, but not dark,
The thin gray cloud is spread on high,
It covers but not hides the sky.
The moon is behind, and at the full;
And yet she looks both small and dull.
The night is chill, the sky is gray;
T'is a month before the month of May,
And the Spring comes slowly up this way.
(S. T. Coleridge, "Christabel")

In the ink and oil drawing titled *Figure 1992*, for instance, a face disappears, up and back into the glaring native light of the paper, as if exploding into a condition of grace. The gesture must mean to say, "Change!" like the

Douglas Max Utter is a painter and writer based in Cleveland, Ohio. He is co-founder of the arts magazine Angle and frequent contributor to a number of journals and newspapers.

startling lines that conclude Rainer Maria Rilke's 1908 poem *Archaic Torso of Apollo –* *"There is no place that does not see you. You must change your life."* The image is a death and a rebirth all in the same immeasurable instant. Deep brownish blacks defining the figure's torso in Kasner's drawing are like the dark body of a tree trunk as it gives birth to the sky, the gun barrel from which transformation is fired. A few ink blots roll like sunspots down from the figure's mouth, and above its right shoulder a curious, looping flight of airy lines maps the passage of some small, gentle thing, perhaps a soul.

Often in Kasner's imagery there are echoes, like the chorus of a song – except these are songs just at the moment they are forgotten, as in between waking and dreaming when the provisional order of reverie unravels; songs such as the dead might try to sing as they crossed the river Lethe. The words and sentences and musical phrases pass in and out of focus, lapsing into silence.

It makes sense that Kasner has been asked to design many CD covers over the past decade or so. Like everything he does, they're just another occasion to mount a search for a passage through the night, but they also take advantage of the affinity his percussive drawing technique has to music — drum solo spatters lending traction to brief melodic arabesques An image he made for the band *Trephine*, for example, is nothing but pure Kasner, and I find it to be one of his most startlingly beautiful images. It's an ink wash study of a head, and typically the artist makes much of a very small gesture: The eyes are downcast and the face is also angled downward, though only slightly, so that the high forehead bulges forward. Just at the uneven, blotted hairline that marks the forehead's disappearance into various levels of spotted darkness, are two large holes, like bullet holes. They define the figure as dead, and his large, curving lips as rictus, and yet this face seems… not dead. It's like the moon, of course, its eyes and mouth and nostrils only shifts in geological make-up, illuminated by reflected light. It is an illusion, but the sort of illusion that is far more real, more true, than any solid object. Each of Kasner's works is a search for the face and form of our indwelling darkness. Like pleasure or pain, they tingle and peak and fade, touching, lingering, slipping away from the thing they seek, taking us in and out of an uneasy sleep in the watches of an endless night.

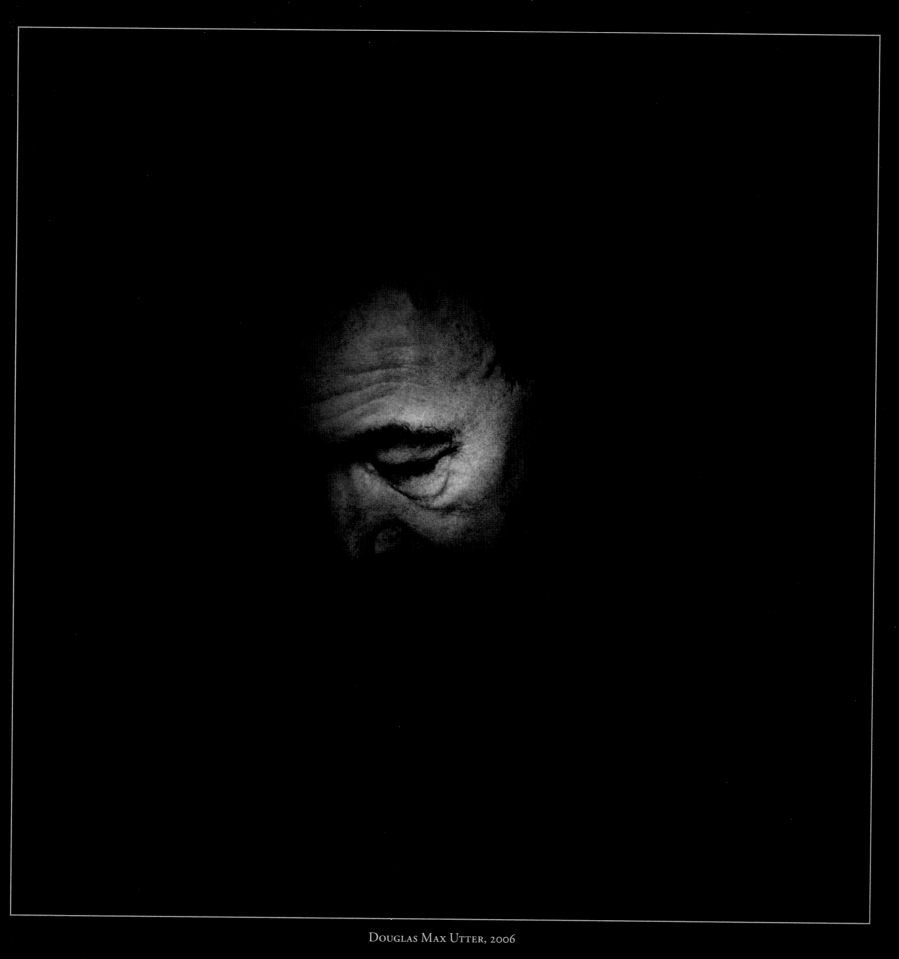

Douglas Max Utter, 2006

ON PAINTING

by Stephen Kasner

Crystallizations are the most potent singular moments that occur in a person's lifetime. They are not the first set of things we feel, but they are the first feelings that contain vital intensity and *psychic charge*. Not merely associations from childhood then, but emotionally saturated details, objects, things, and ideas that are infused with an energy that recur in our desires and objectives throughout adult life. Crystallizations are moments and their properties which we consciously or unconsciously carry through our lives, that mold and shape who we are, what we adore, what we strive for, and what we tend to seek in our own desires and yearning for joy.

I have a crude drawing that I did when I was three years old. It is the oldest drawing I have from my childhood, and ironically, it happens to be the very piece which crystallized the power of created image in me.

My mother worked from home as a seamstress, drapery maker, and interior decorator. Her workshop in our home on west side of Cleveland was often my

afternoon playroom. I spent many afternoons underneath her enormous worktable, which was my private sanctuary, where I mostly daydreamed. Very often, I would climb underneath with a box of crayons, pencils, and pens, and begin drawing on the inside of the large, wooden legs and the underside of the monstrous tabletop. Before long, almost every square inch of this private chamber was covered. One afternoon, quietly doing my work, with a handful of black and red crayons, I created a particular drawing. It wasn't terribly unlike many of the others I had done, but there was something very new about this one to me. Almost immediately upon completing it, I sensed a strange set of emotions that were very foreign to me. For the first time in my very short and fragile life, I experienced an emotional reaction to the drawing. I sensed fear, terror, otherworldliness; I sensed that I had, for the first time ever, created something that was larger than me, that held it's own power, and that was now alive on it's own. These feelings were so strong,

that I immediately fled my private workshop clubhouse and sprinted to my bedroom. The feelings continued; I was so filled with fear whenever I was near the drawing again, I simply could not look at it. It was my own specter and yet, I could not bring myself to destroy it. This was the crystallization of my experience with art, and of the power and intensity of drawing.

As I grew older, I completely forgot about this drawing, along with the rest of my primitive graffiti beneath my mother's worktable. Years later, the time came when the table had had enough, as it began leaning and growing old. My mother called me to come and take the table down and remove it. I was older and already moved out of the house by then. She too had moved and the worktable had seen several residences. I came to the place where it last stood and prepared to put the old worktable to rest, and I was not timid about it. I hacked away at it, piece by piece, with hammer and hatchet. As I got the top off the old table, now smaller to my world

UNTITLED.
Crayon on wood, 18 x 3.5" 1973

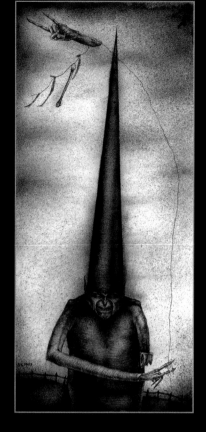

No. THIRTEEN.
Ink on paper, 22 x 10" 1993

but still the largest table I had ever seen, it revealed it's ancient skeleton. With hammer in hand, I pummeled one of the main side rails and split it in two. The piece cracked loud, and like some magic castle door, one half of the rail swung slowly open with a rigid creak. There, right before me, after several decades of lurking, was the drawing. The one that had filled me with complete terror so many years ago, the one which I had long since forgotten. When I saw it this time, however, it perplexed me in an entirely new way. It was familiar to me beyond a sense of simple nostalgia and reminiscence. Not an archaic reminder, but a strange and starkly connected link from past to present.

❧

The first serious works I ever accomplished were possibly my most unconsciously executed. Just as I was graduating from the Cleveland Institute of Art, in an attempt to purge and shed much of what I had learned,

I had prepared three canvases. I worked and reworked these three pieces non-stop for several weeks, never once having a particular goal to capture a specific image. These were an exercise in painting, freedom, and intuitive decision. As I continued with these, side by side by side, one after the other, this somewhat familiar and repeated shape began to fill each space. I slowly began to hone into what I saw buried within the canvases and thick, confused paint. These three pieces became my *Dreamscape* series in 1993.

What had occurred to me that afternoon, while I was dismantling my mother's worktable and was rejoined with my old spectral drawing, were the eerie similarities that this purely unconscious crayon drawing had to my current work, particularly my *Dreamscape* paintings. The gesture of the figures, the shape of the shoulders, the colors, and even the eerie faces I had uncovered, appeared as sons and daughters and brothers and sisters of one another. It was unmistakably familiar.

❧

Immediately after I had completed the *Dreamscape* series, I began working on a set of ink drawings. These tedious and intensely detailed works were a continued exercise in unconscious thinking, but were also the first group of drawings I had done of their kind and most interestingly, done without reference of a live figure model. Until this point, my drawings were more traditional; mostly graphite and charcoal figure works, exclusively rendered in studio from live models. These ink drawings, predominantly created in 1994, were the antithesis of my figure drawing work. These were spontaneous, surreal, intuitive, and wandering, much like the *Dreamscape* and *Torso* works on paper I had done earlier. However, these drawings were tightly rendered, finely and painstakingly worked with microscopic care for weeks on end.

Like the *Dreamscape* paintings, I used no reference for any of the ink drawings of this period. Each and every one began with

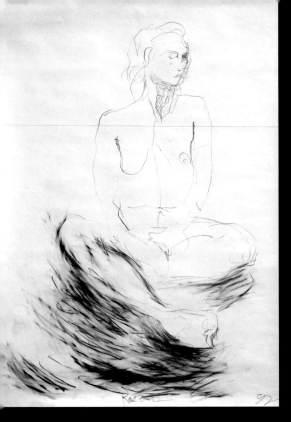

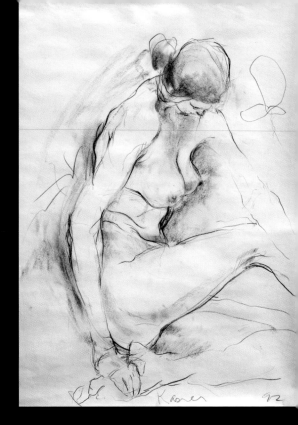

one small mark on randomly sized papers, and grew organically outward. Similarly to the paintings, I let them build on their own, seemingly without destination. Once I began to see certain forms, I fixed onto them, and carefully built them up to an almost obsessively detailed completion.

☙

After these series of early works, I began investigating other means of unconscious visual interpretation. My works turned inward and more personal, setting up a continuous succession of paintings, drawings, and photographs that focused on a loose form of dream interpretation, which continue to this day.

I have always been an extremely vivid dreamer. Some of the most intense and vivid dreams I have ever experienced, I had when I was a child. My memories begin around age three, coincidentally, around the same period as the aforementioned

Dreamscape premonition crayon drawing. The dreams then were wildly fascinating, and intensely overwhelming for my young mind's comprehension (and even now). These were dreams of darkness; black rooms, total absence of light, extreme foreboding, utter aloneness, familiar surroundings saturated in completely unfamiliar energies, disembodied and invisible hands, a tangible sense of the presence of beings yet none actually visualized, apocalyptic landscapes, sinking ships, drowning invalids completely incapable of being helped to safety, red skies, gray clouds, destruction, and ghosts. But the ghosts in my dreams then, and now, do not have any semblance of fictional qualities to them. Even after waking, I am aware of their presence; the air around me seems to hold them for a moment, lingering and looming.

It is these elements and countless other dreams and dream states that I can recall with ease. They fill me with endless curiosity, and my work has become a way of refining their meanings and connecting them to

reality through kinetic interpretation. This is not to suggest that my work is scientific- far from it. My paintings are completely free of intentional scientific analysis. Additionally, my work is not an attempt to illustrate what I see in these dreams, but more about addressing an emotional impression of events and moods and happenings within these myriad, elusive states. It is about attempting to connect an emotional and psychic bridge between unconscious hallucination and reality. It is the joining hands of night and day, and of dark and light. An attempt at making sense of an irrational world, using tools deeply seeded in the brain to do it.

☙

There are several elements that have become unintentionally iconic in my work. They are repeated forms, figures, florals, birds, and blackened faces that seem to repeat themselves in an ever-evolving suggestion of birth, growth, enlightenment, and death

They are just that- elements, but specifically, elements of the earth that have particular resonance for me. I am a figurative painter. The human figure is an object I have always used to convey emotions. After all, we are humans. We relate to one another in a very specific way, and emotions and energies are transmitted between us with certain, concrete associations and understanding.

There are other elements in nature that we all communicate with, on various levels and for different reasons; things that we relate to on many emotional levels. In my work, I tend to gravitate toward a few delicate objects, mainly flowers and birds, which symbolize sheer beauty and perfection in my world. I utilize these sensitive objects to offset the balance between the darkness of the earth, and that which flourishes within it. These are symbols of a delicate idealism. They are survivors in a perpetually blackening world. They are easily destroyed, yet they continue to bloom and bound in floating, crawling, majestic, completeness and personal

achievement. They are the messengers who translate the code of these dreams, and they are sometimes the dreams themselves, weaving in and out of reality and solid state, commingling with cornucopian fogs of unconsciousness.

For me, these dreams and ideals are heavily married with concepts of memory and how we are able to recall highly specific emotional states connected to momentary events in our lives. Loss, love, yearning, and devotion are only a few strong emotions connected with my work repeatedly. Like the impressionistic interpretation of dream states, memory is recorded in an often semi-conscious manner, in an attempt to capture immediacy of personal recall; an event, a moment, someone. Ultimately, I admire the fact that the act of painting is a physical recording of a singular or succession of emotions, channeled specifically or subconsciously in it's own moment(s) of time. Memory or memories serve as a tool in it's process, but each work holds it's own personal

momentum, sustaining itself permanently as a diagram of the feelings and motions and actions that brought it into being.

Dreams and actual memory often become blurred and weave in between one another. Our dreams are connected to our consciousness, and so being, we dream of people and moments we have known. Dreams reinterpret these events and the people within them in ways beyond what can be described as simply unique. They also contain apparent visions of the future and of the unknown past.

There is no rational way these ideas can be taken to painting. It is a battle between subconscious memory and cognizance in the attempt at interpretation. My goal is more aligned with the intention of physically transcribing these ideas of dream and memory recollection while avoiding any literal elements contained in them. I am more interested in recreating emotionally charged moments, real or *imagined*.

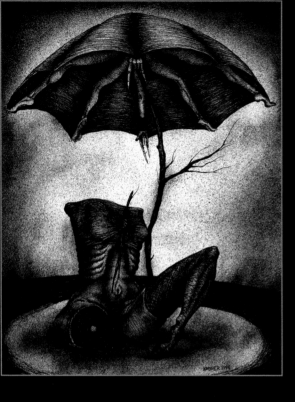

TOURNIQUET.
Ink on paper, 11 x 8.5" 1994

THE FIRST GREETER.
Ink on paper, 20 x 16" 1994

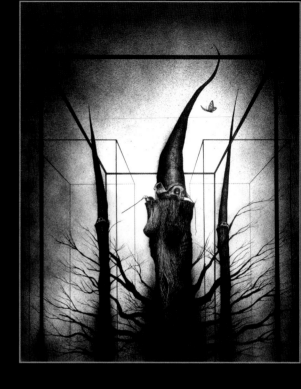

My drawings are a natural extension of my paintings, though I execute them much differently. In creating works on paper, I use the paper itself as a physical element in the life of the piece. With oil on canvas, the action is more about building layers of paint and glazes, but very often while working on paper, I similarly build layers, but then work to remove them, aggressively scrubbing and grinding back into the paper. This creates a much different effect in the final result. There are things that can occur on paper that can never be duplicated on canvas, and it is interesting to use those properties to my advantage, and to properly honor it's exquisite, unique surface. I am comfortable in differentiating between canvas and paper works, since they truly are two completely different mediums, and will handle the same paint and style of painting very differently.

Dreams, memory and the refinement of *crystallized moments* remain the primary forces propelling my work, in an effort to create a continuous, fluid recording of a life in flux. It is, though, equally my goal to allow the paintings to exist independently, on their own, and beyond my personal realm of exploration. Very often my titles are not designated based on what personal memory and emotion may have inspired them. Rather, after the works are completed, they assume independence and are titled with their own individual personality, with perhaps only a trace of the emotional details which brought them into being. The paintings reach a point where they grow beyond anything I ever intend them to be. It is a slight shift, a mild moment, a weird instant, and suddenly they are like children who have grown too large for my arms. That is how I know they are complete.

DRAWINGS
PAINTINGS
PRINTS

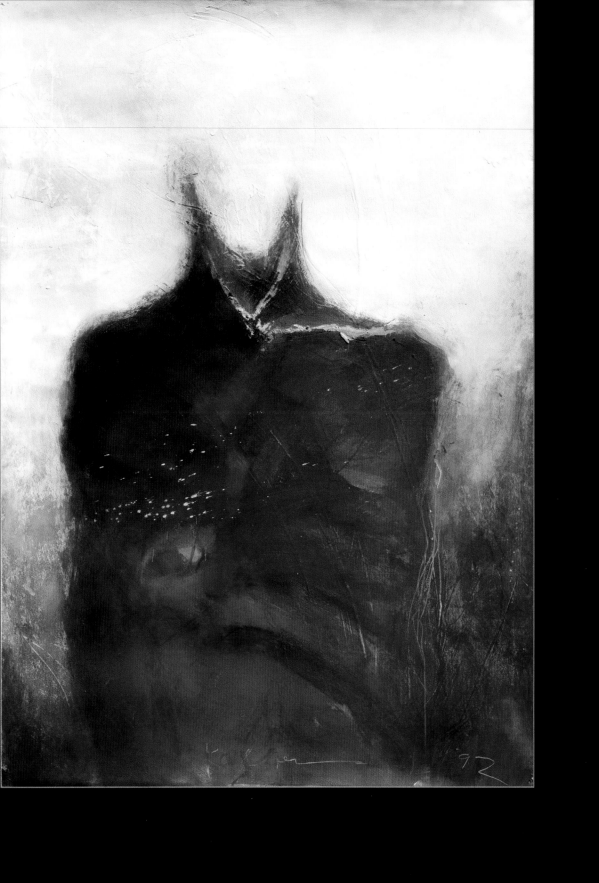
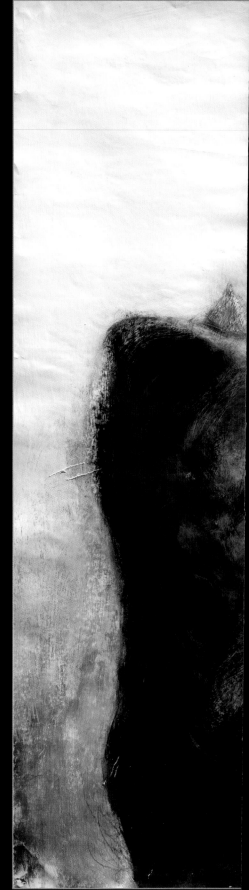

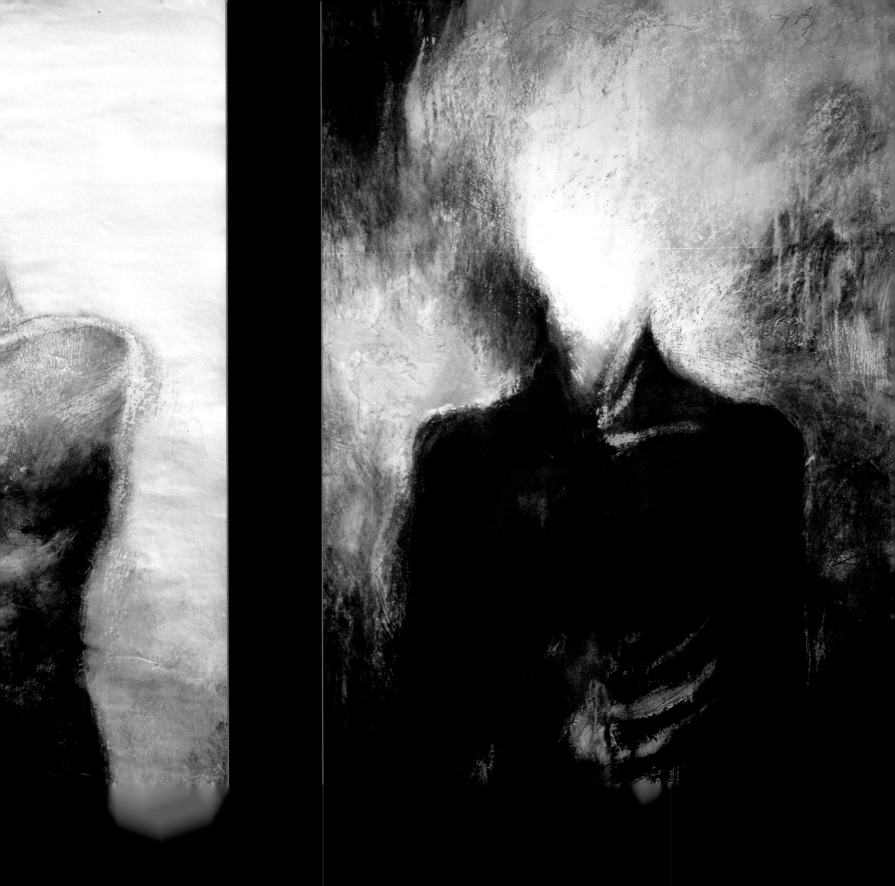

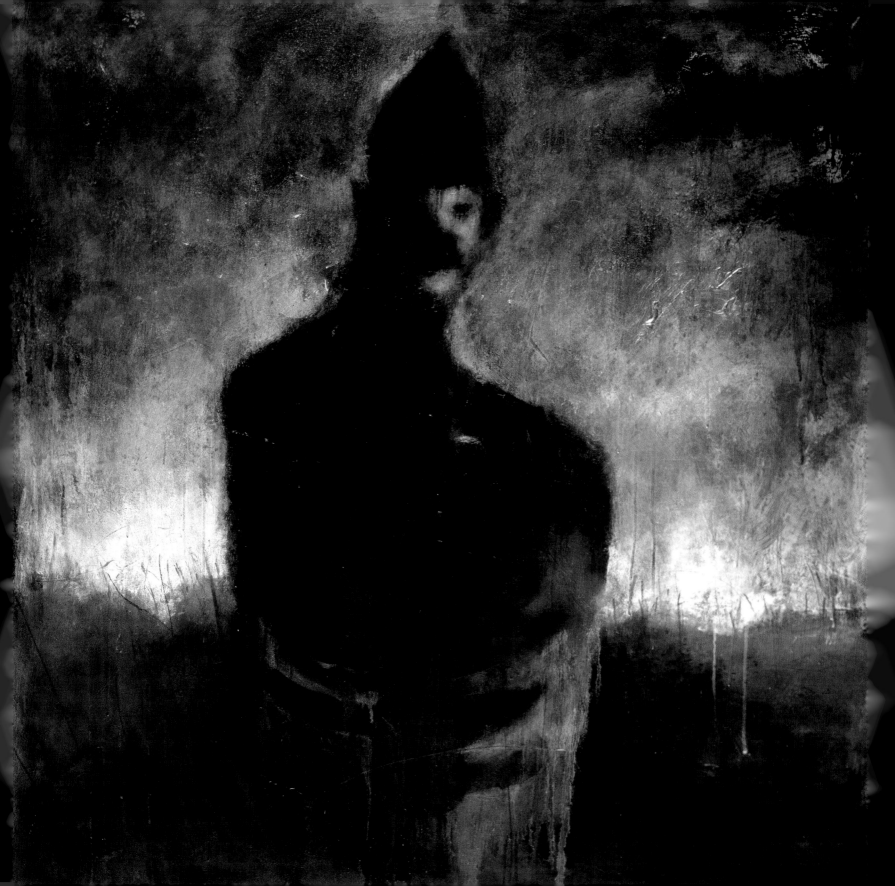

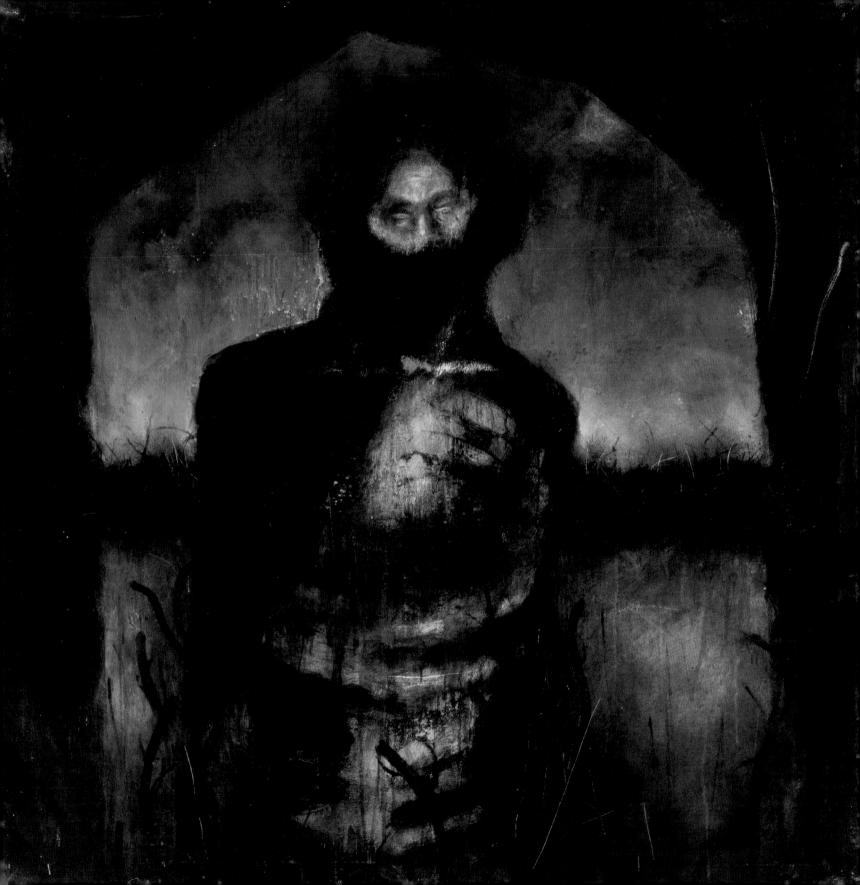

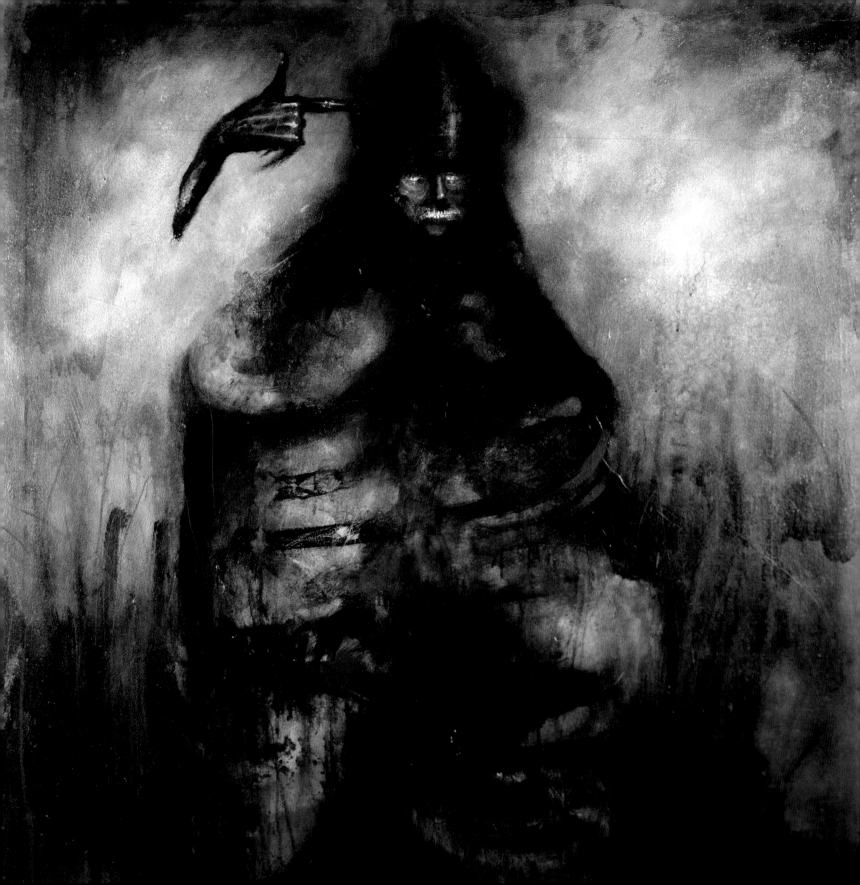

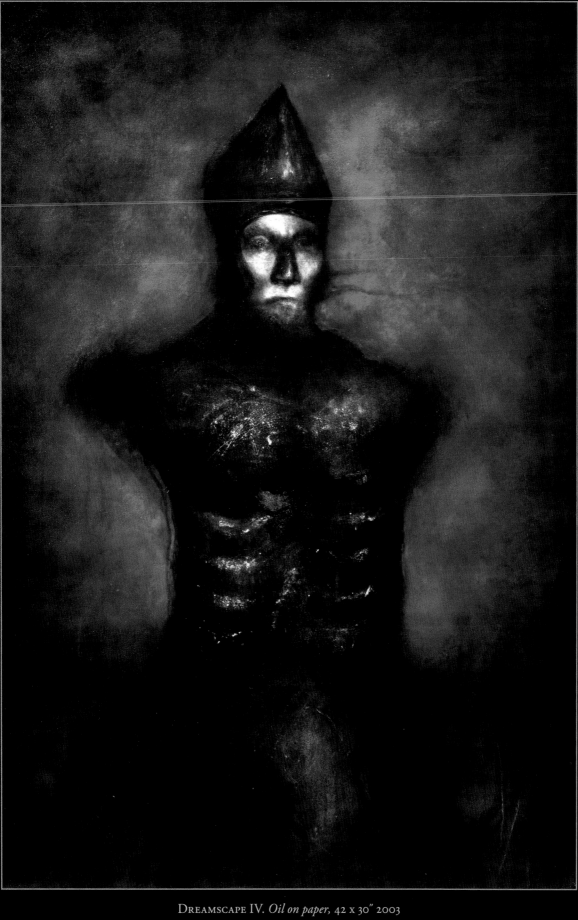

DREAMSCAPE IV. *Oil on paper,* 42 x 30" 2003

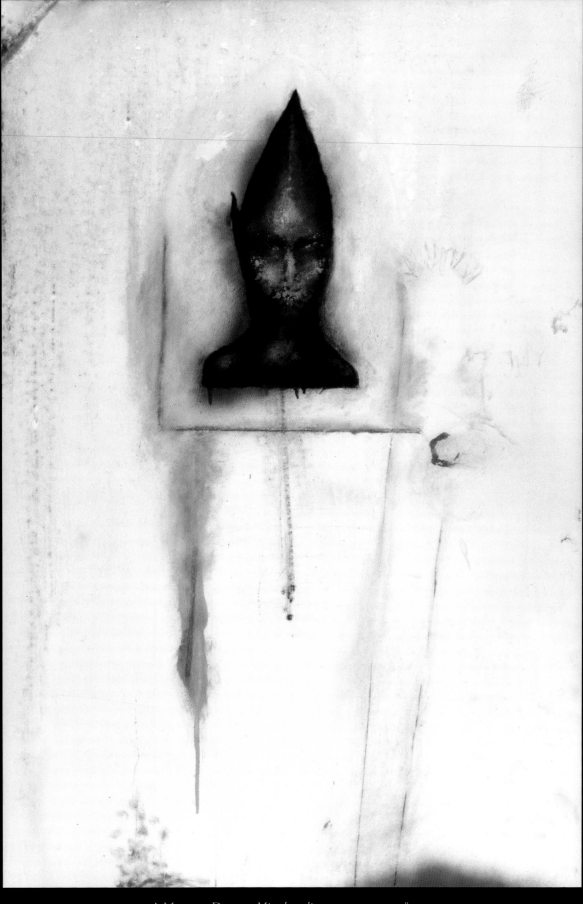

A Mask of Death. *Mixed media on paper,* 44 x 30″ 1997

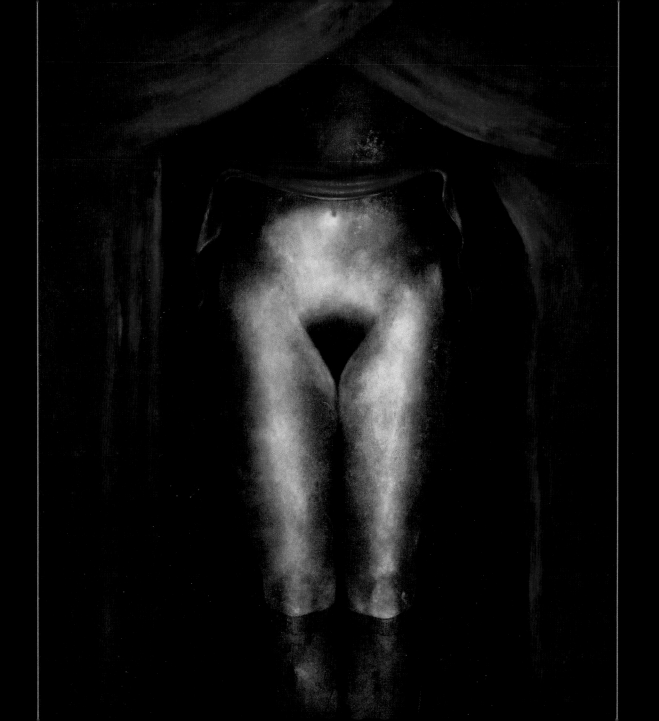

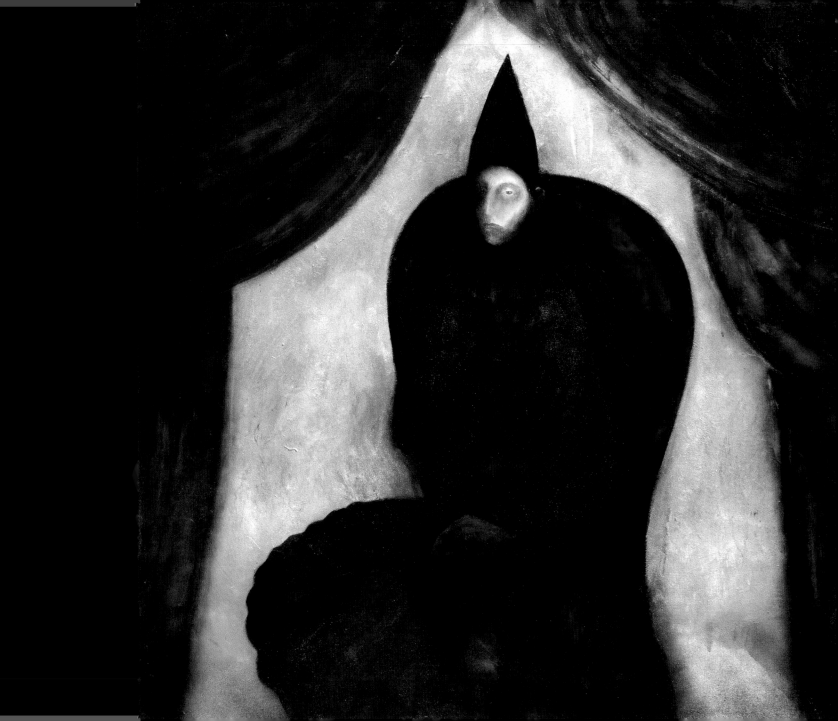

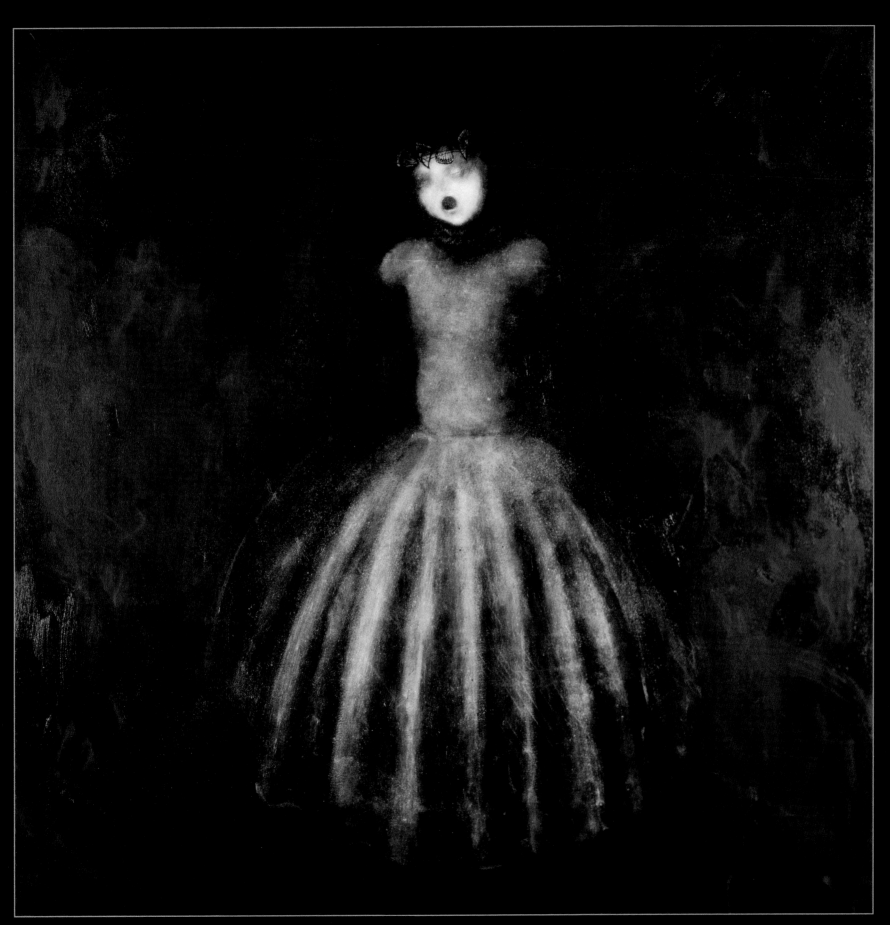

YOUNG COLLECTOR OF WINGS AND NOTES, *Oil on canvas, 48 x 48" 1997*

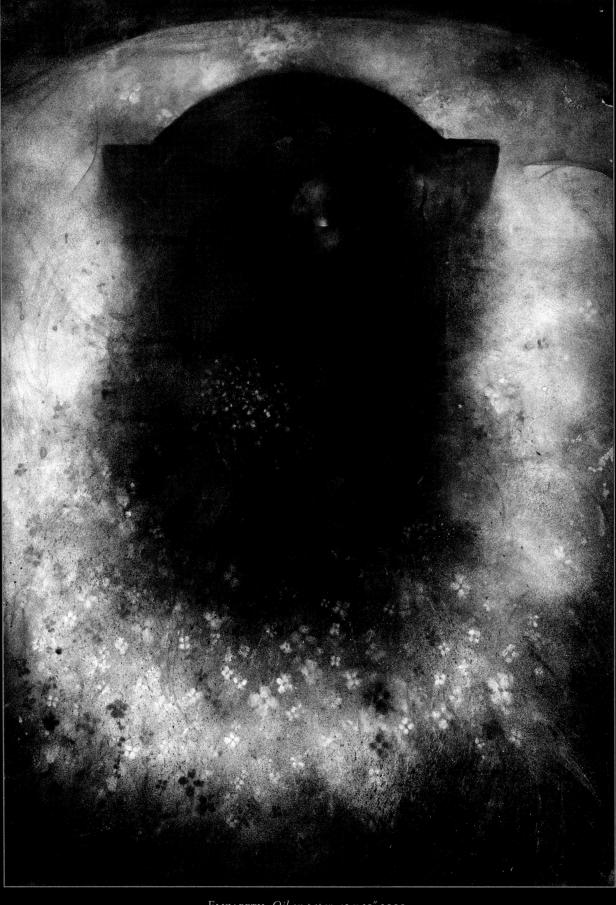

ELIZABETH. *Oil on paper,* 42 x 30" 2000

36

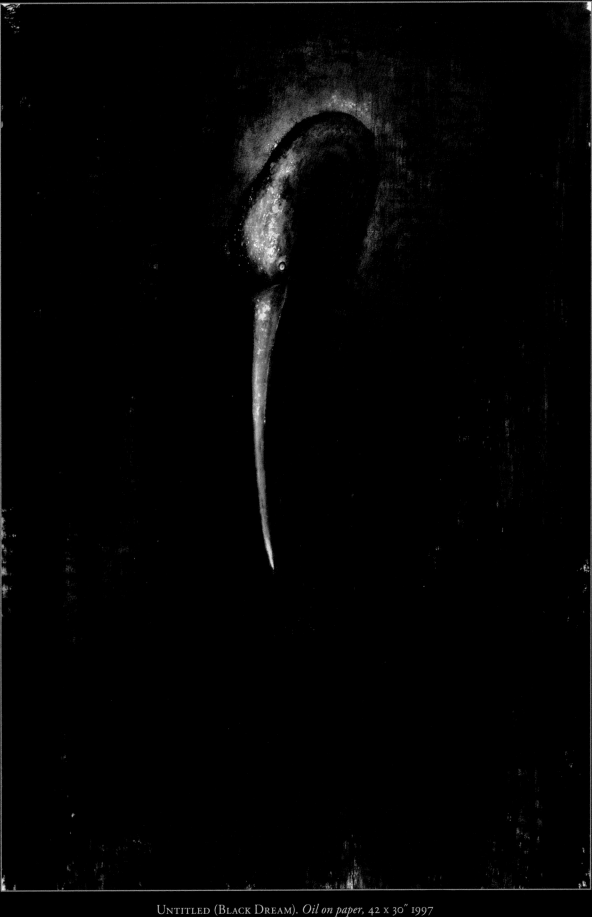

UNTITLED (BLACK DREAM). *Oil on paper,* 42 x 30″ 1997

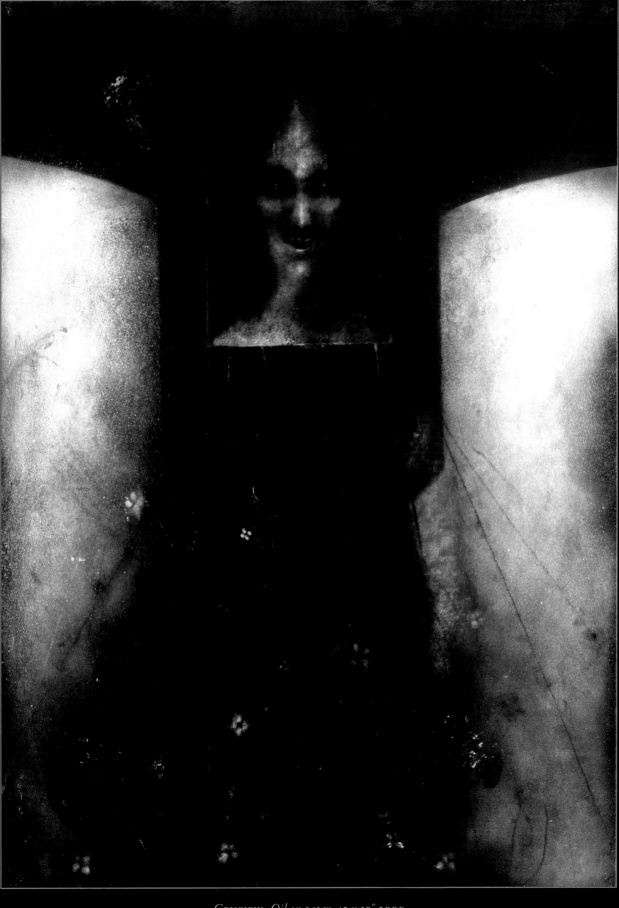

CRUCIFIX. *Oil on paper,* 42 x 30" 2000

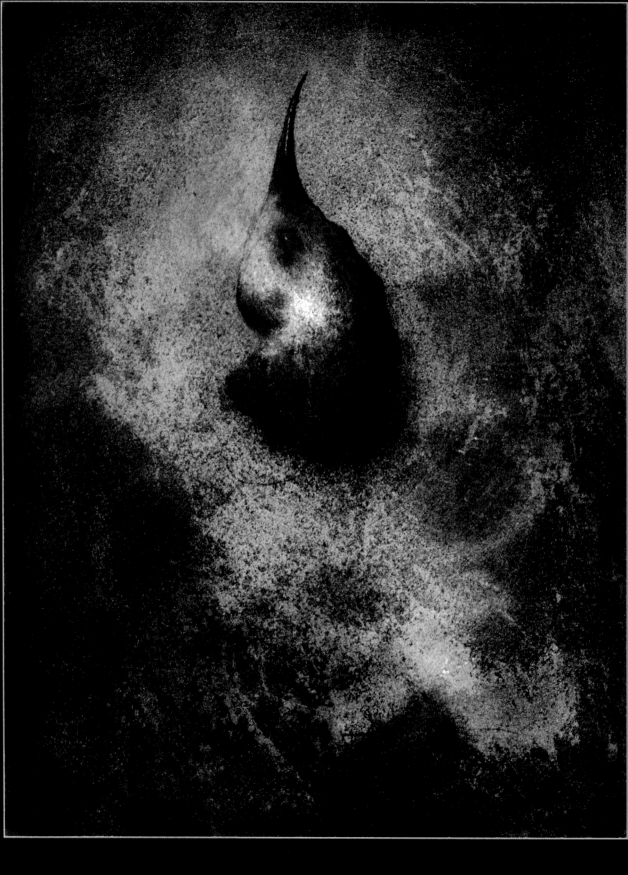

UNTITLED. *Ink on paper,* 11 x 9" 2002

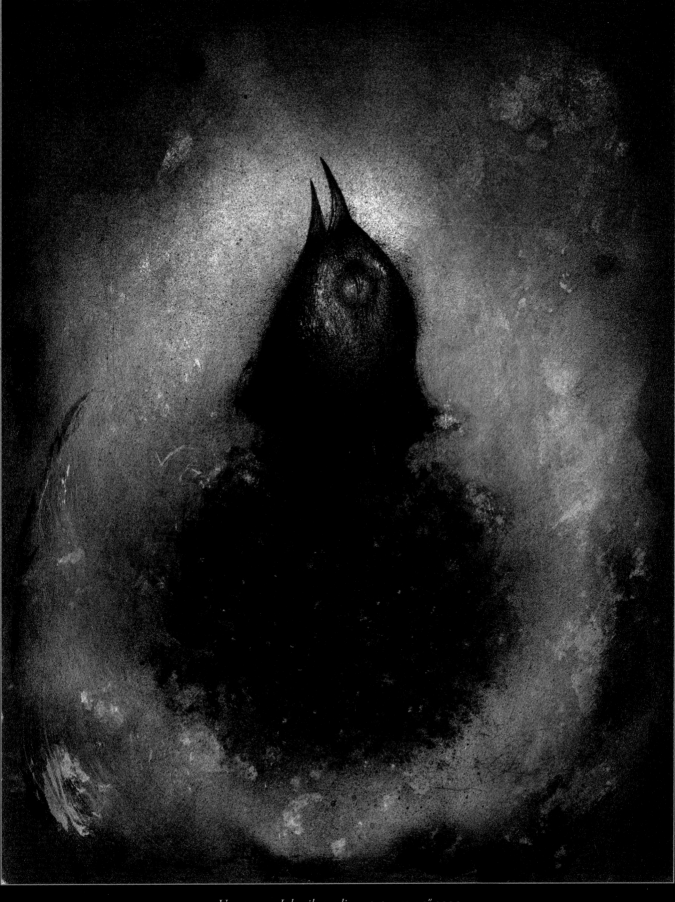

UNTITLED. *Ink, oil, acrylic on paper,* 11 x 9" 2000

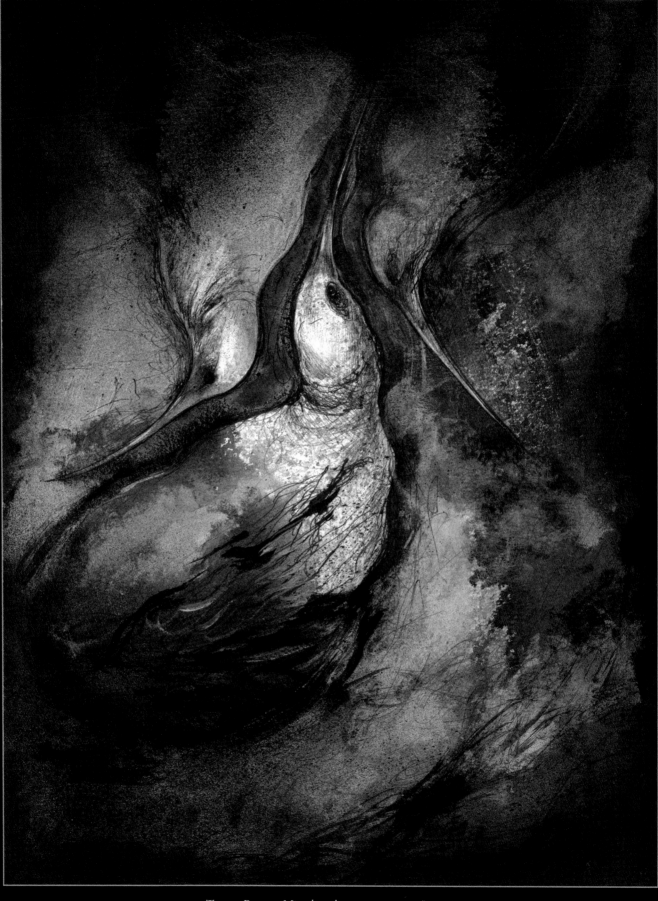

THREE BIRDS. *Mixed media on paper,* 11 x 9″ 2006

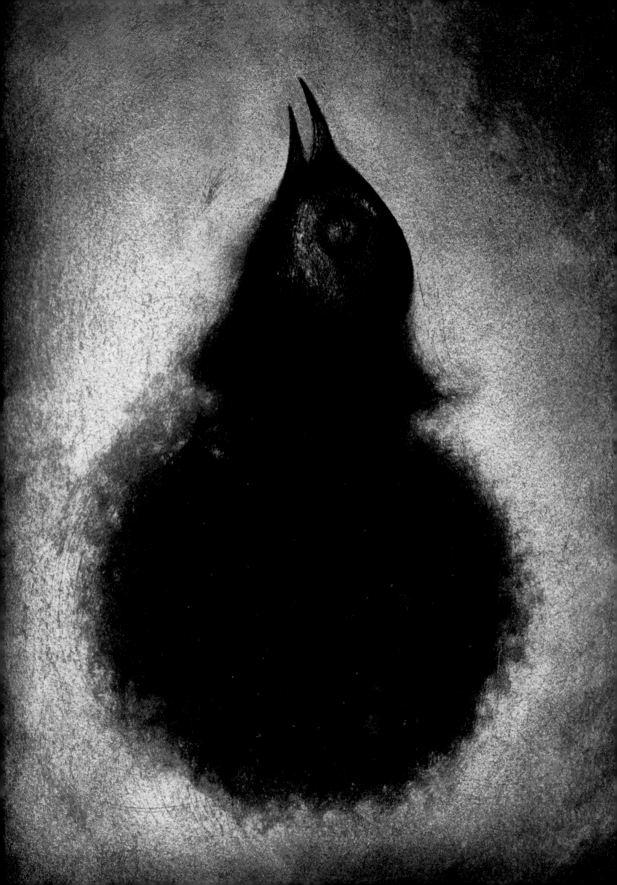

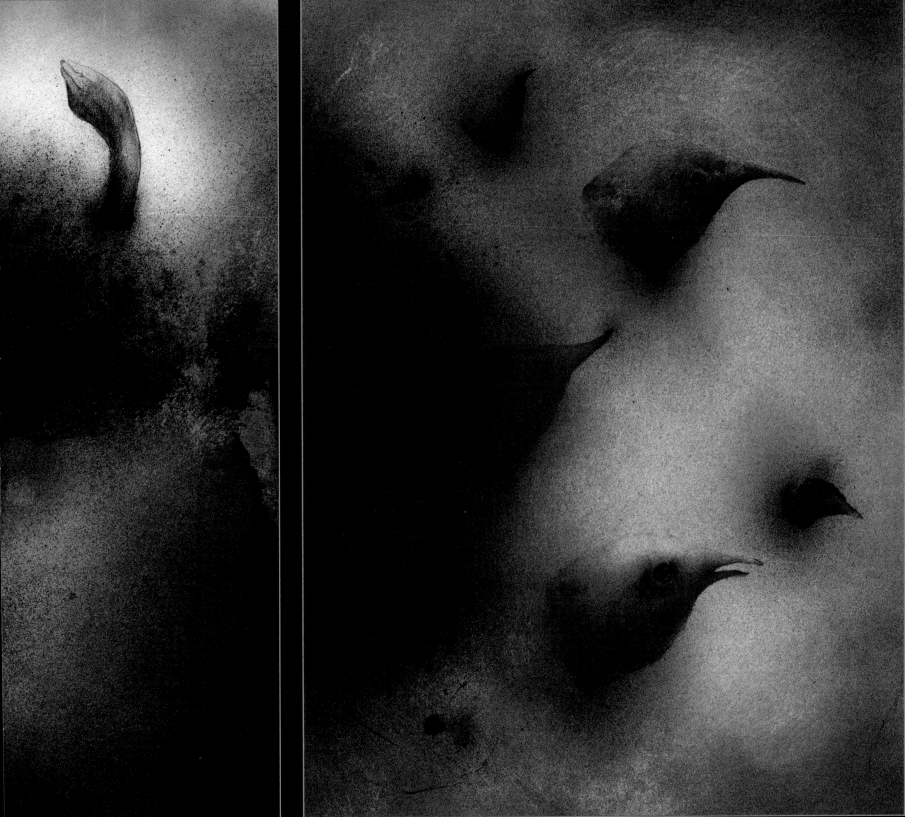

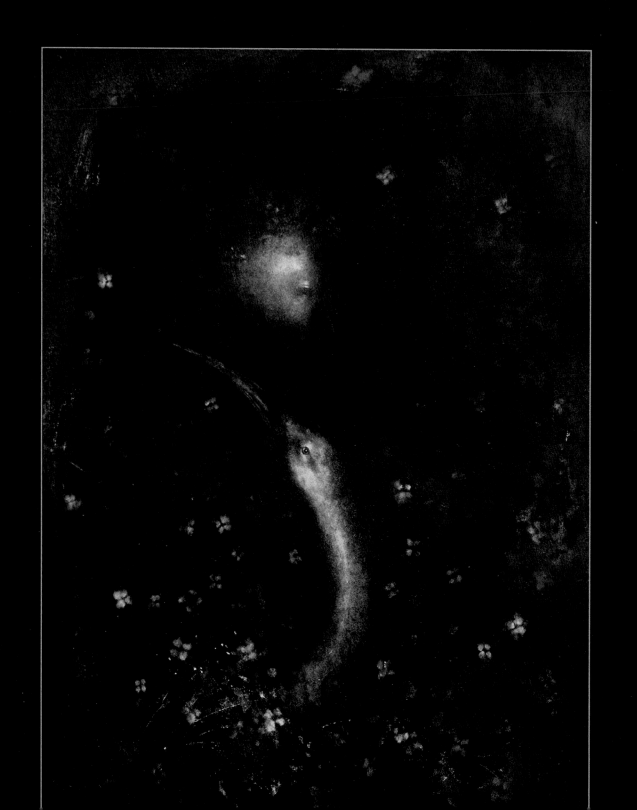

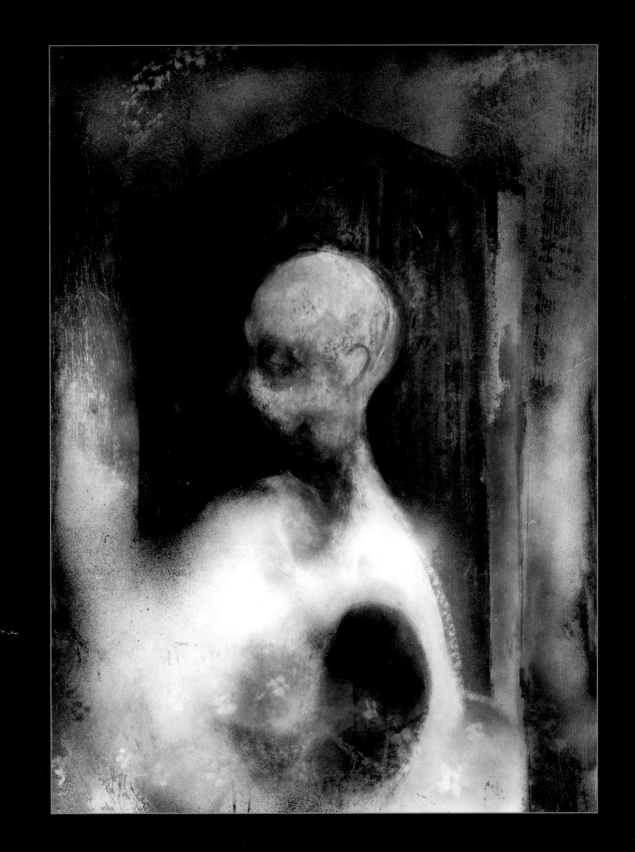

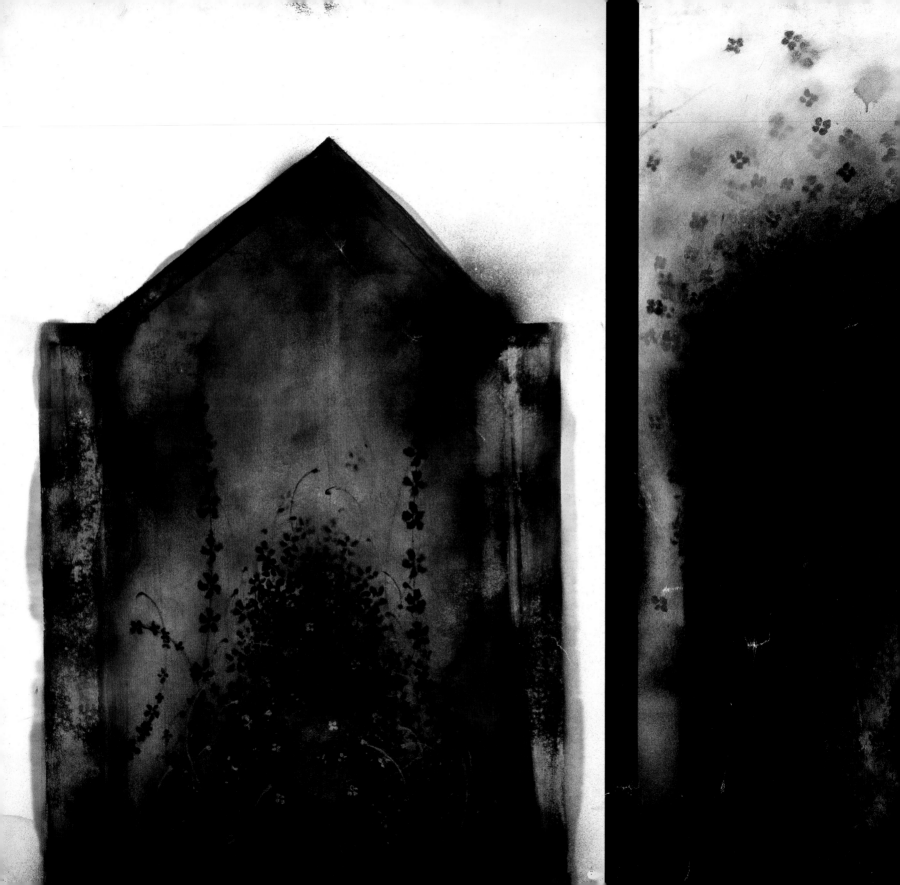

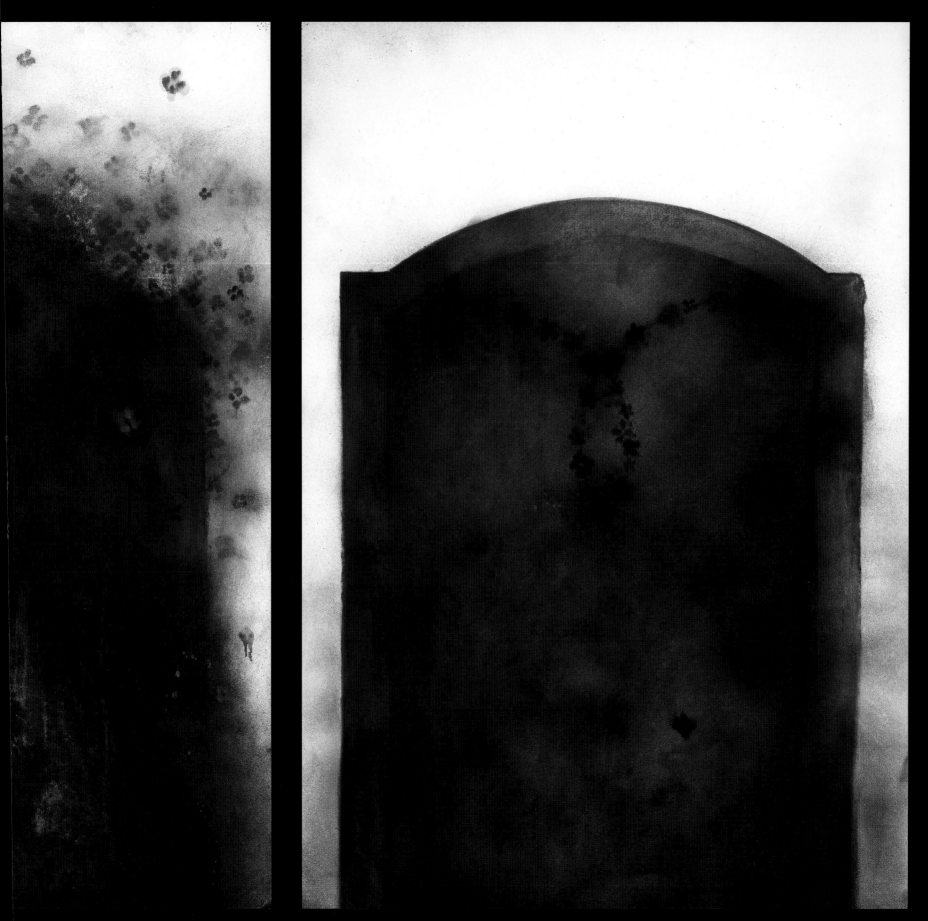

MONUMENT II. *Oil on paper*, 42 x 30" 1999

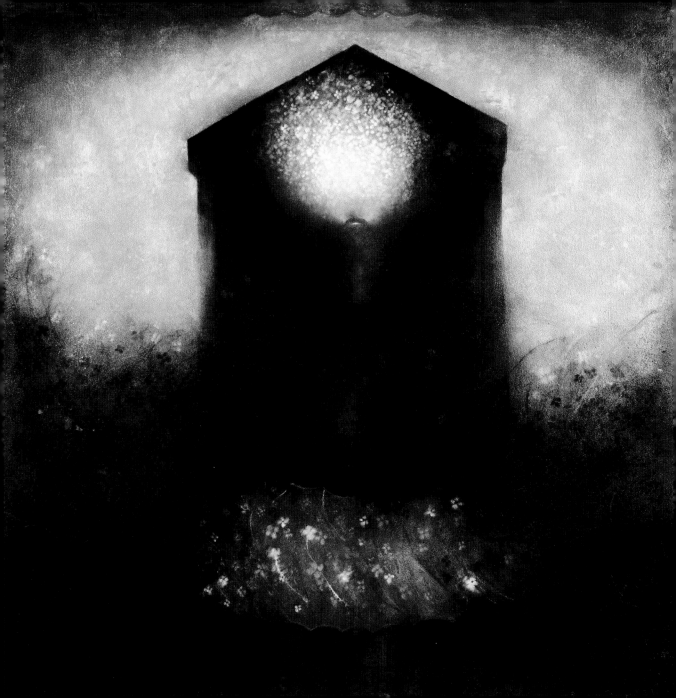

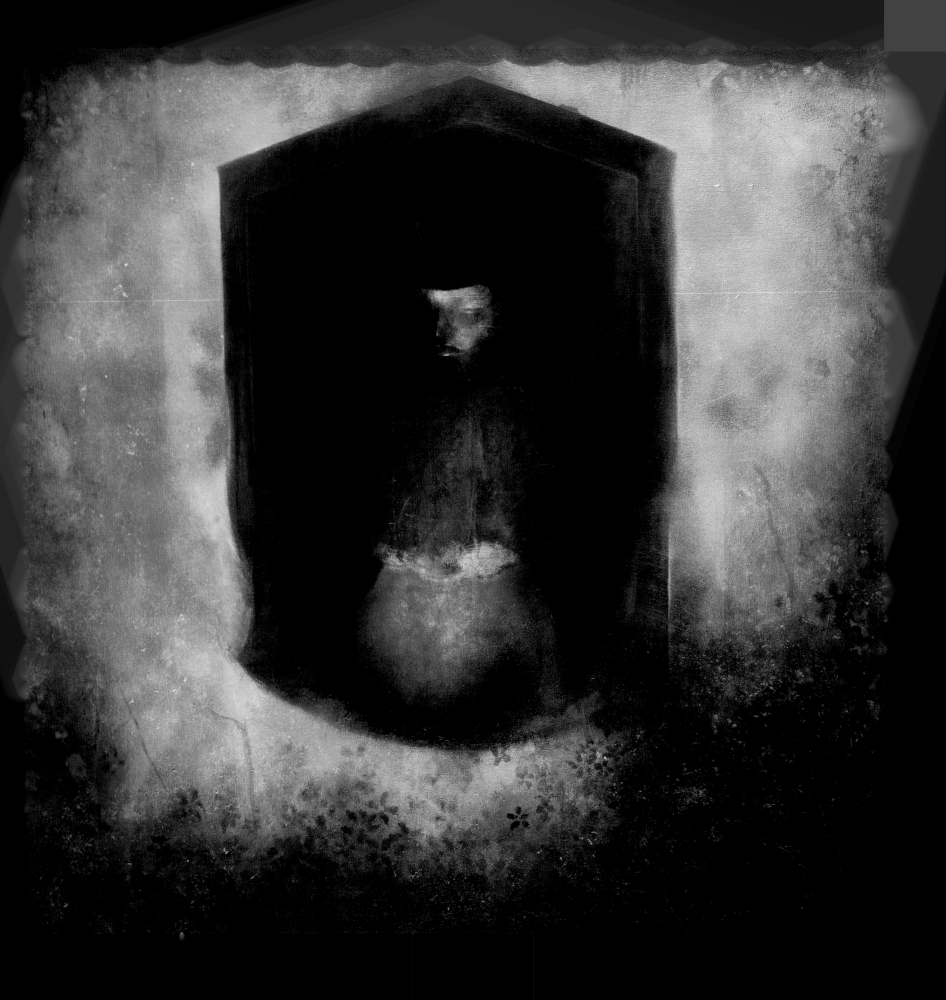

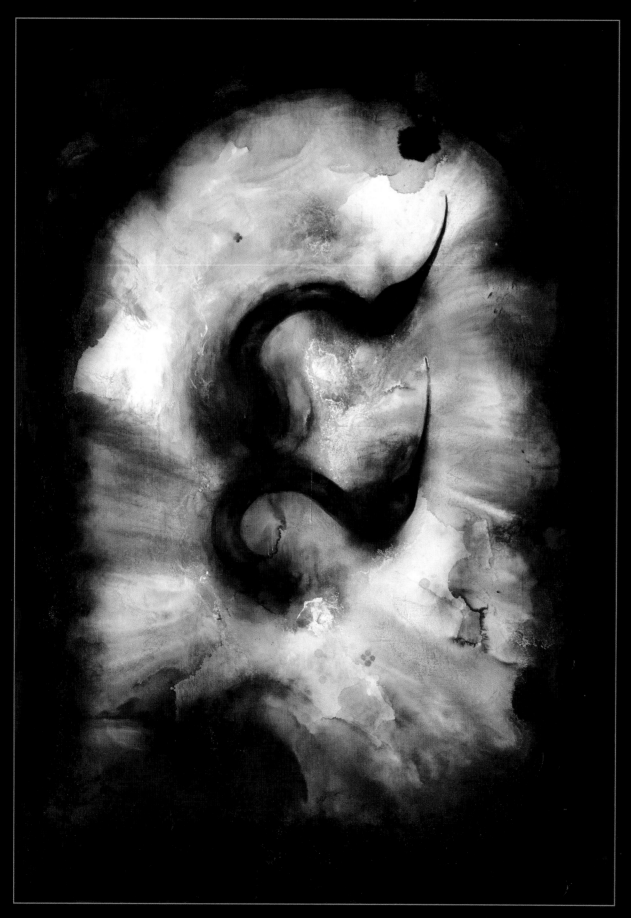

I Love You. *Oil on canvas,* 81 x 57" 2002

UNTITLED. *Mixed media on paper, 22 x 22" 2002*

EVERYTHING. *Oil on canvas*, 48 x 48" 1998

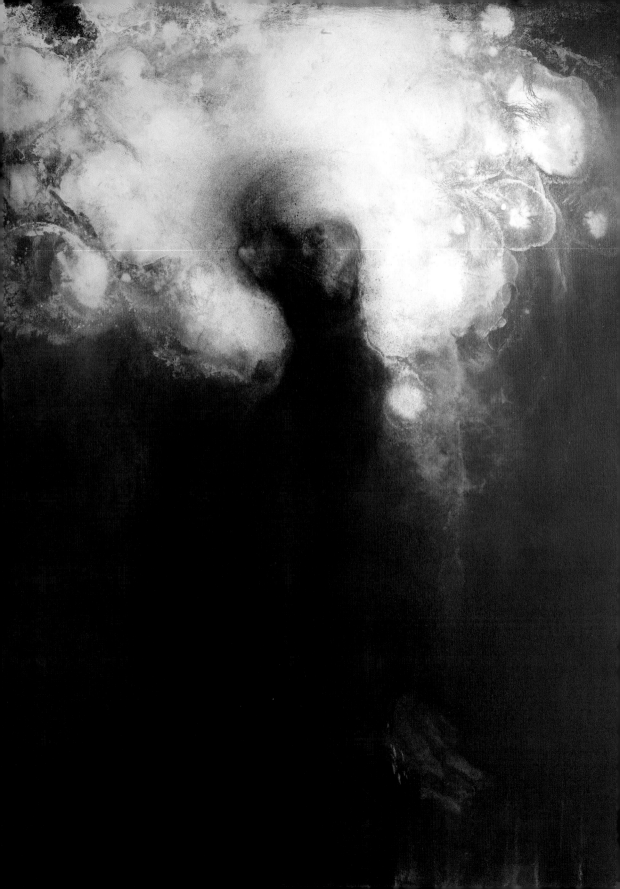

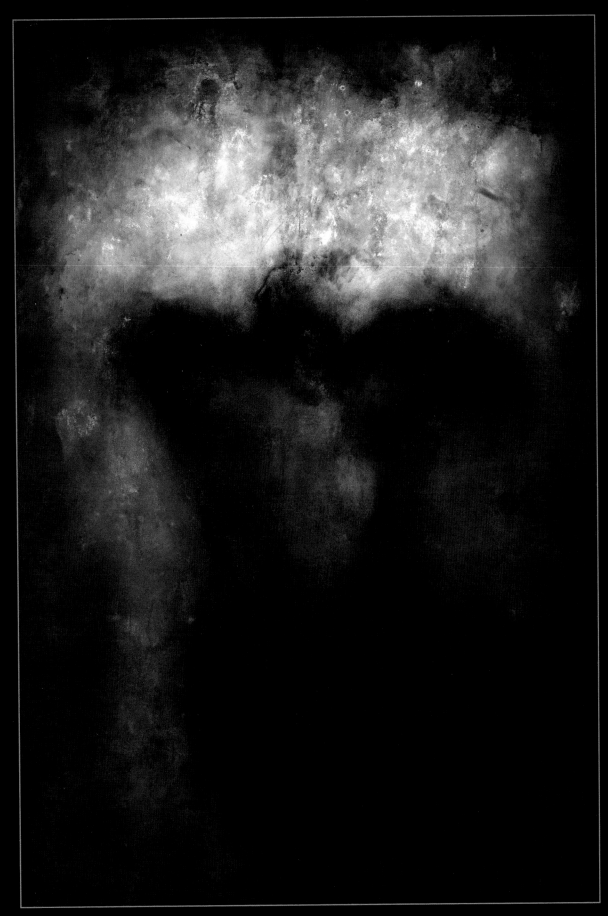

FALLING WOMAN. *Oil on paper,* 42 x 30″ 2002

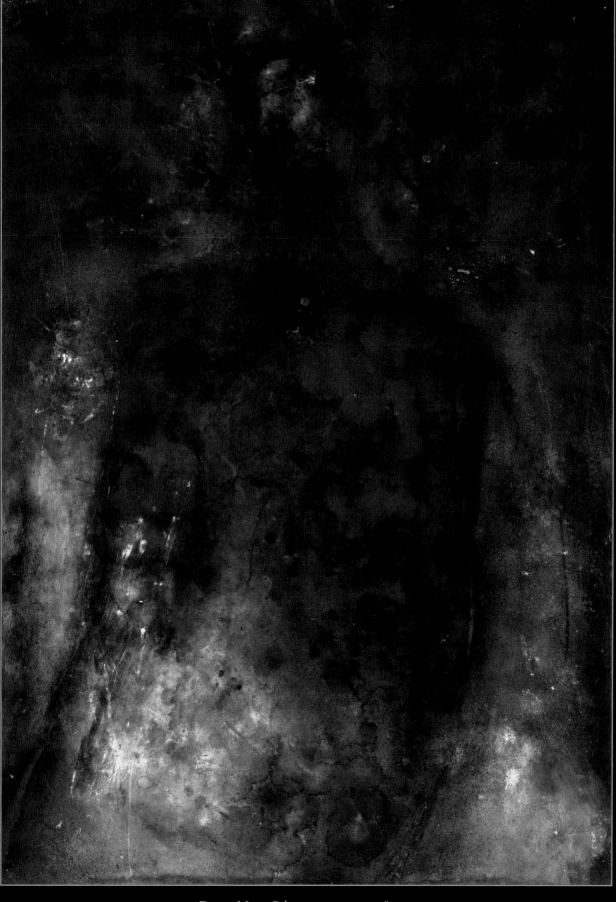

DYING MAN. *Oil on paper,* 41.5 x 29.5″ 2002

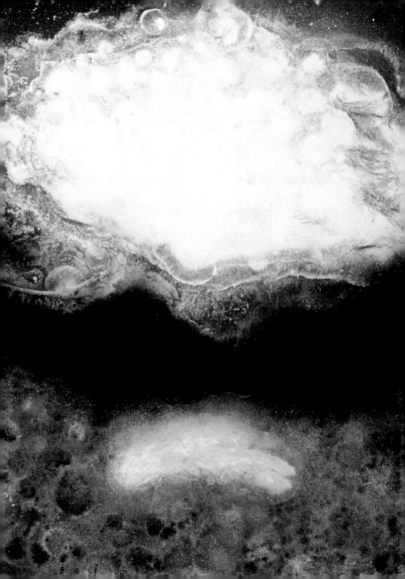

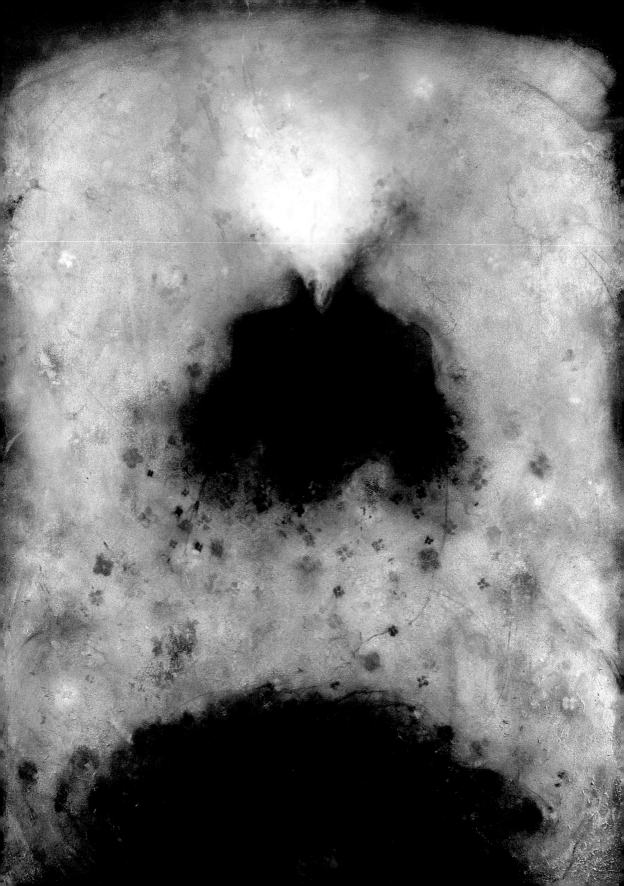

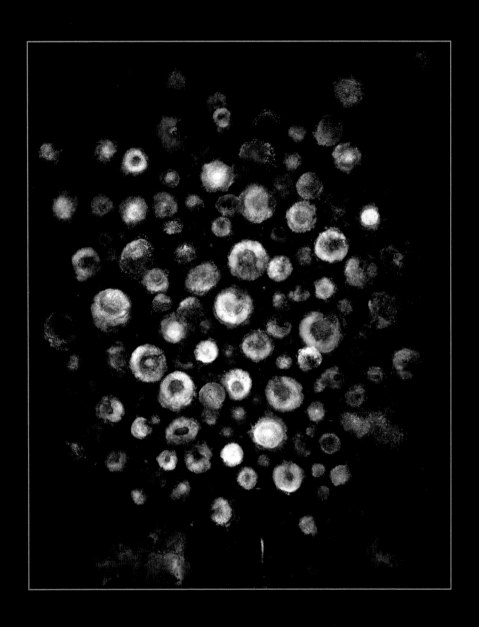

FLOWERS AND VASE. *Oil on canvas,* 40 x 32″ 2005

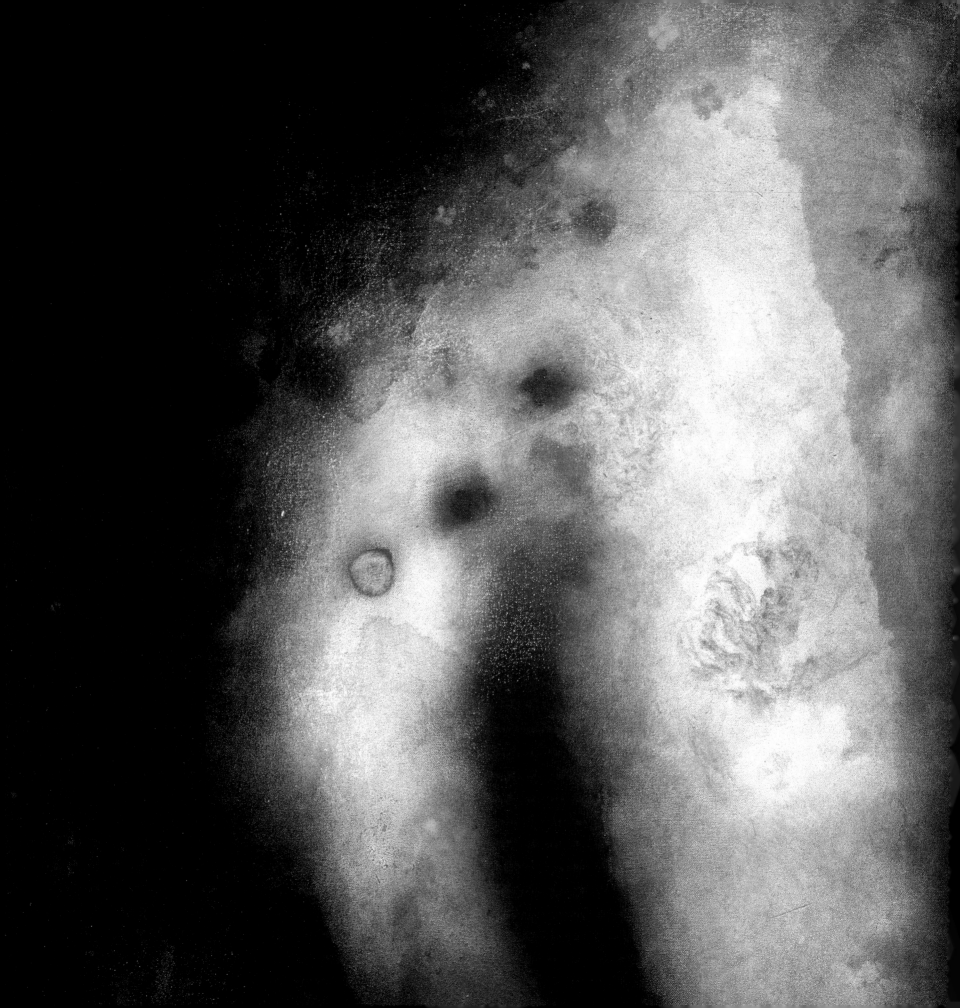

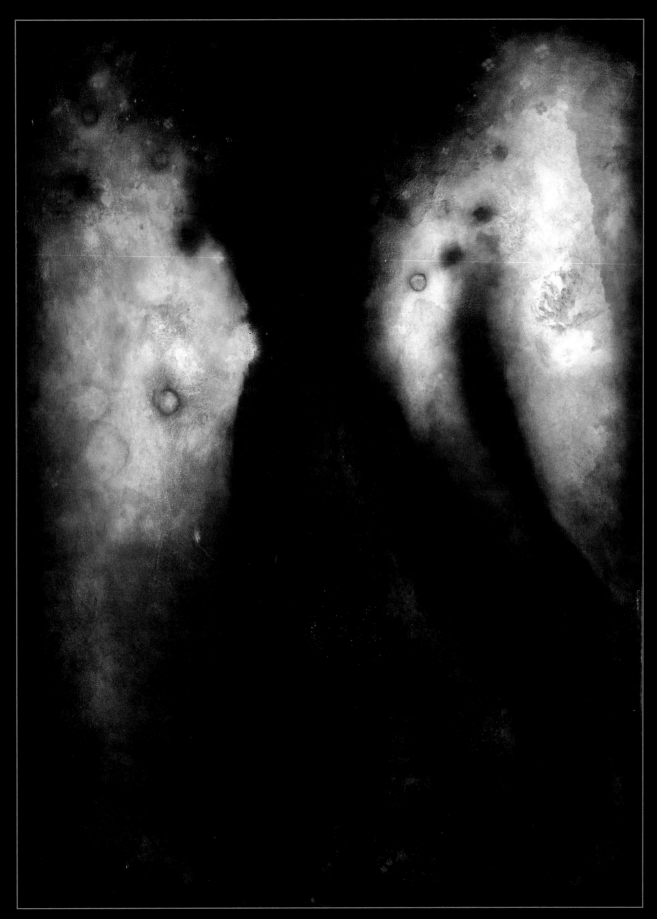

WOMAN WITH ARM. *Oil on canvas*, 66 x 48" 2000

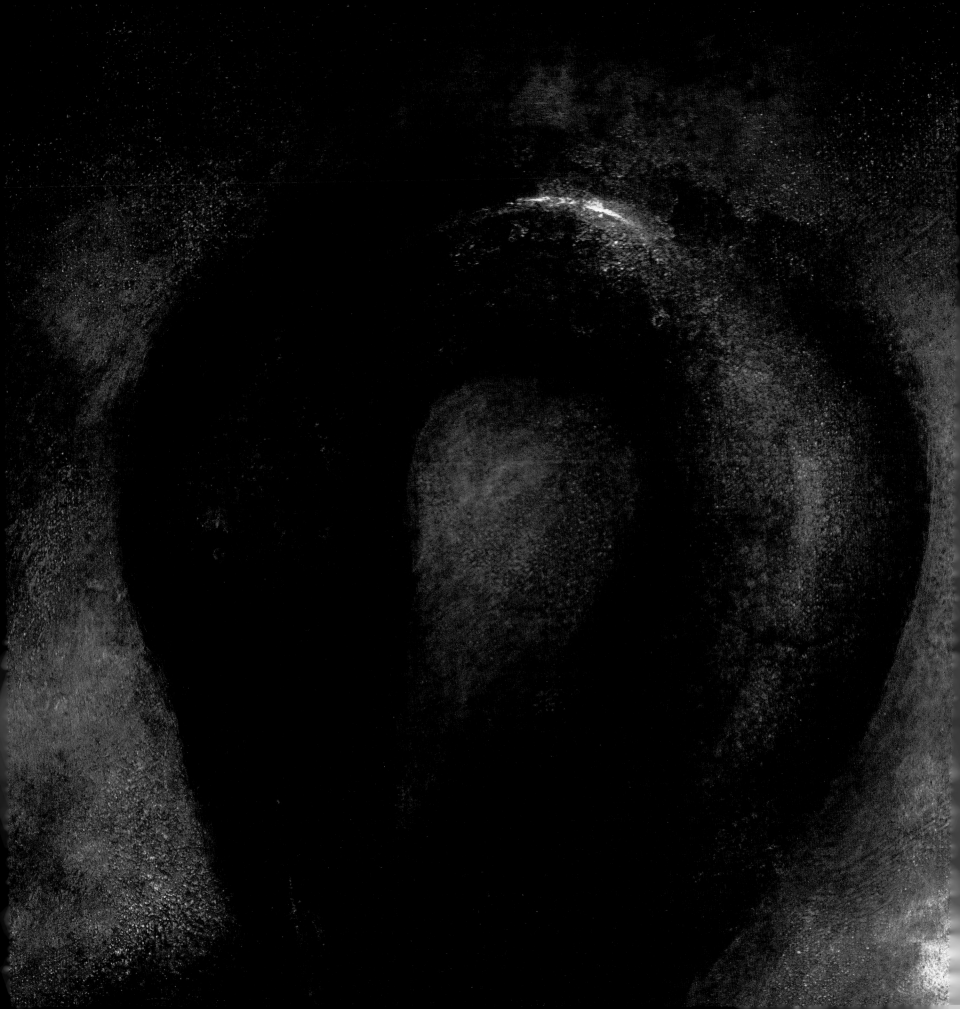

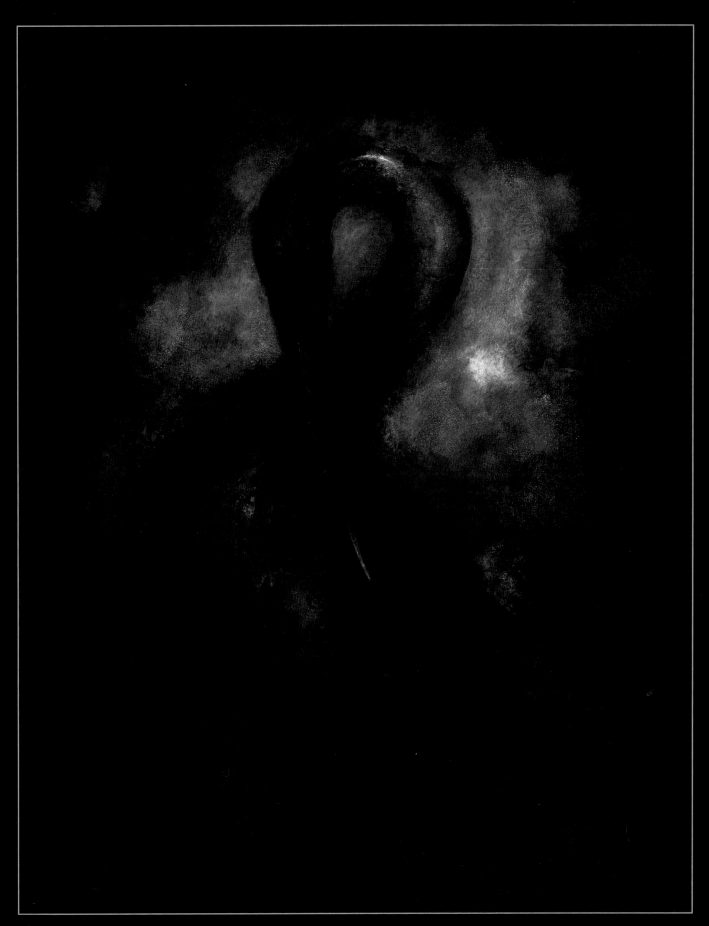

STUDY FOR SELF-PORTRAIT. *Oil on canvas*, 40 x 32" 2005

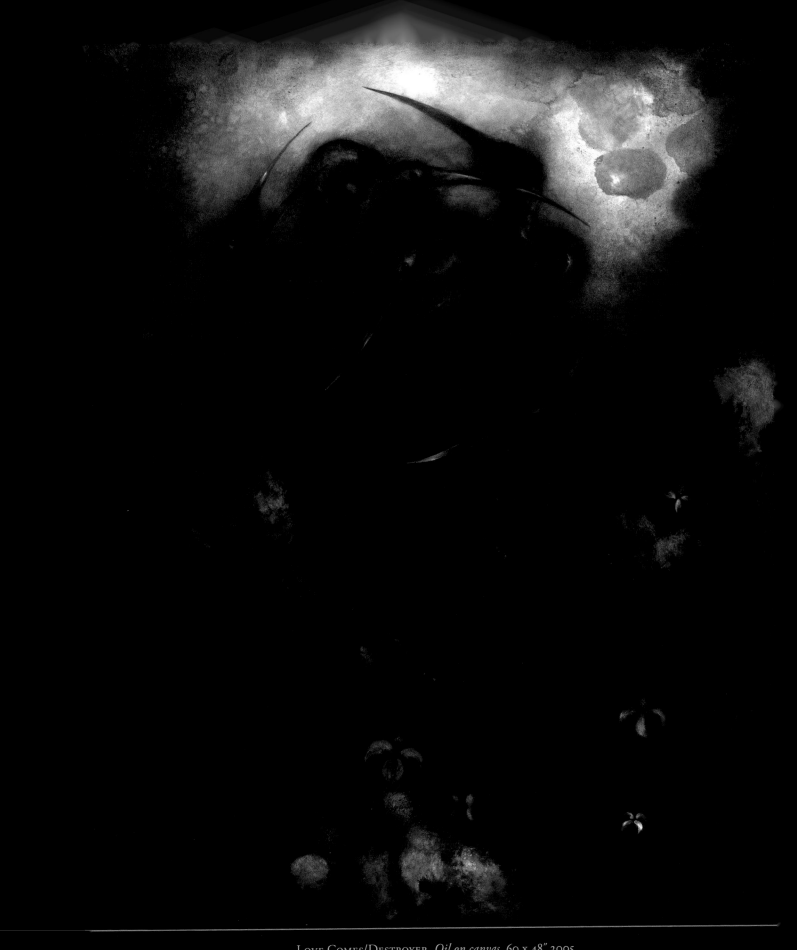

Love Comes/Destroyer *Oil on canvas, 60 x 48" 2005*

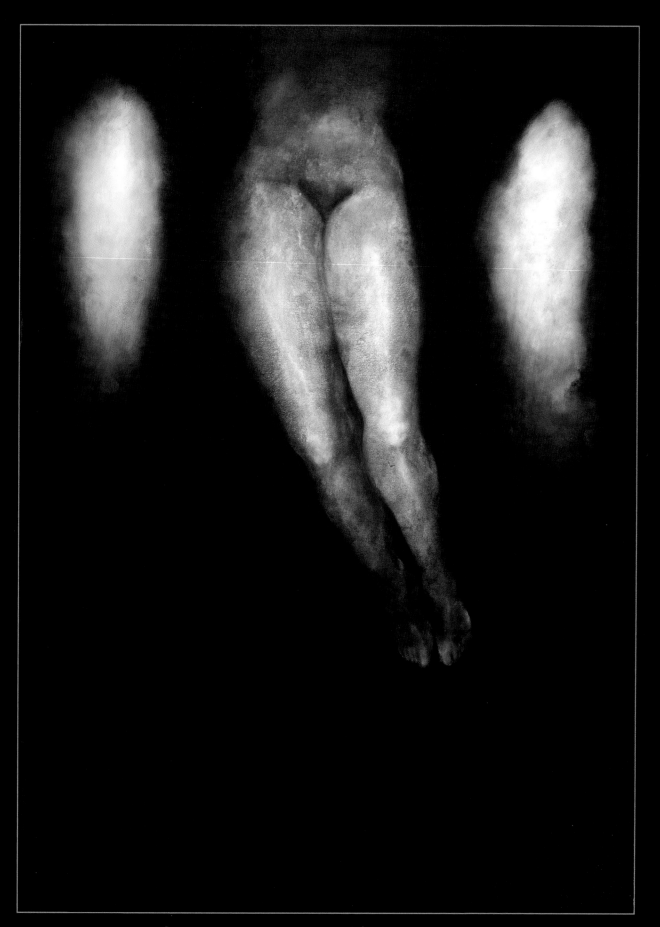

STUDY FOR WOMAN WITH CLOUDS. *Oil on canvas*, 66 x 48" 2005

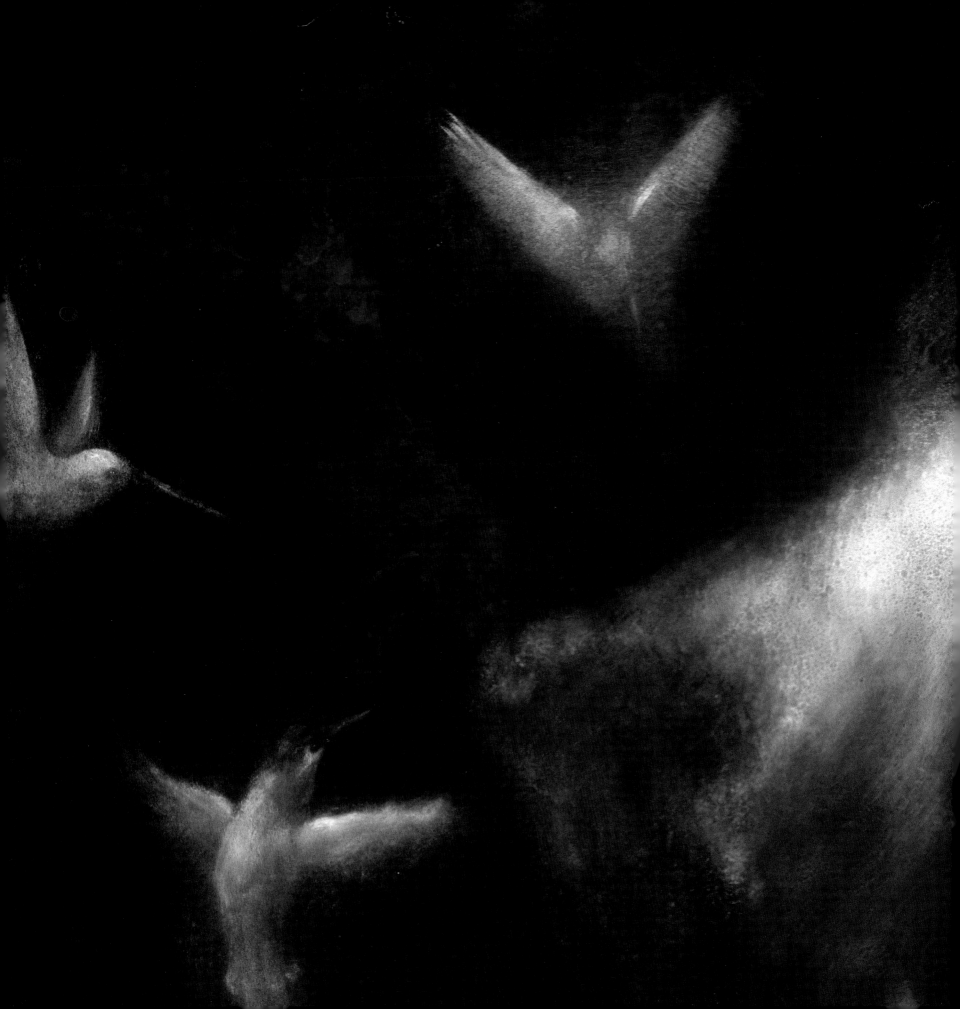

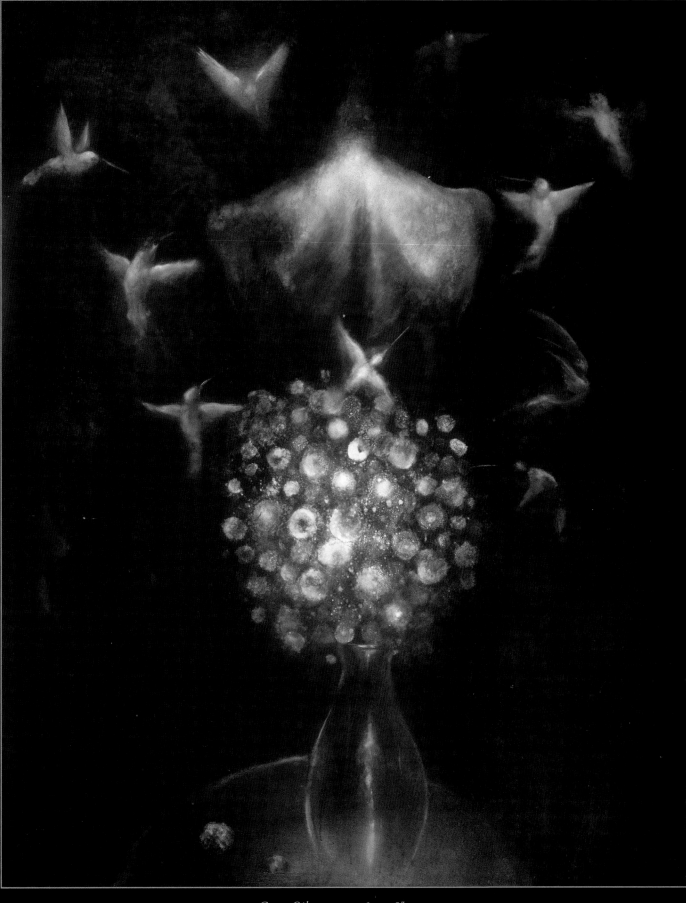

GIFT. *Oil on canvas*, 60 x 48" 2005

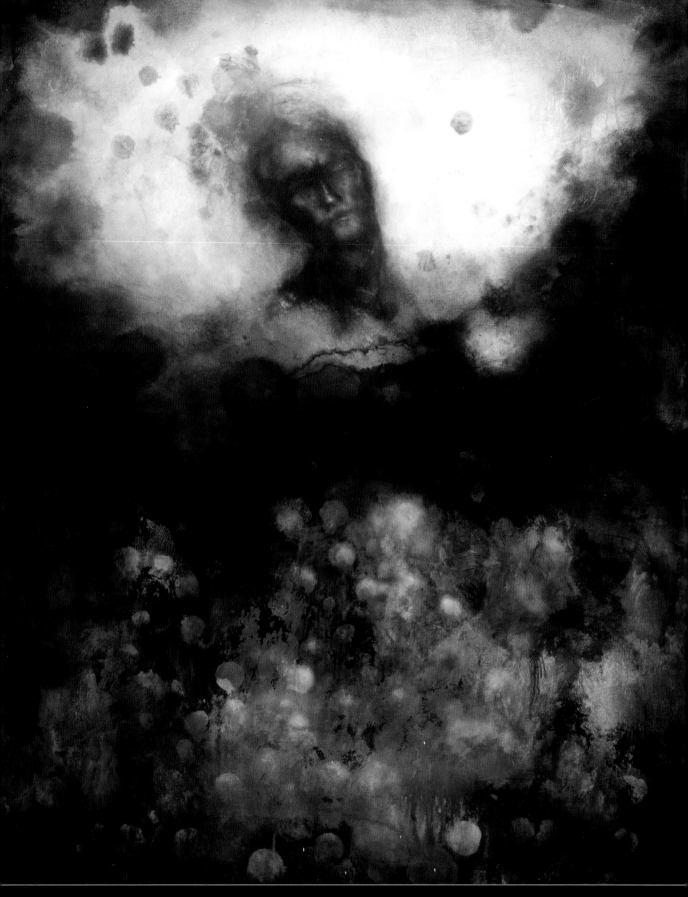

SLEEPING MAN WITH CLOUD FRAGMENTS (THAT WHICH IS MOST VITAL MUST FIRST BECOME POSSIBLE). *Oil on canvas, 60 x 48", 2004*

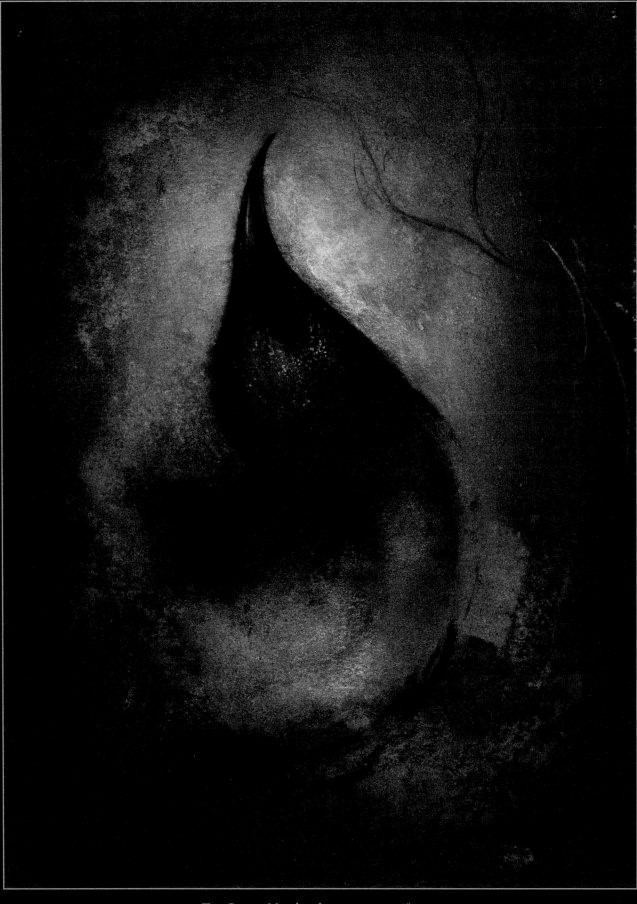

TWO BIRDS. *Mixed media on paper,* 11 x 8″ 2005

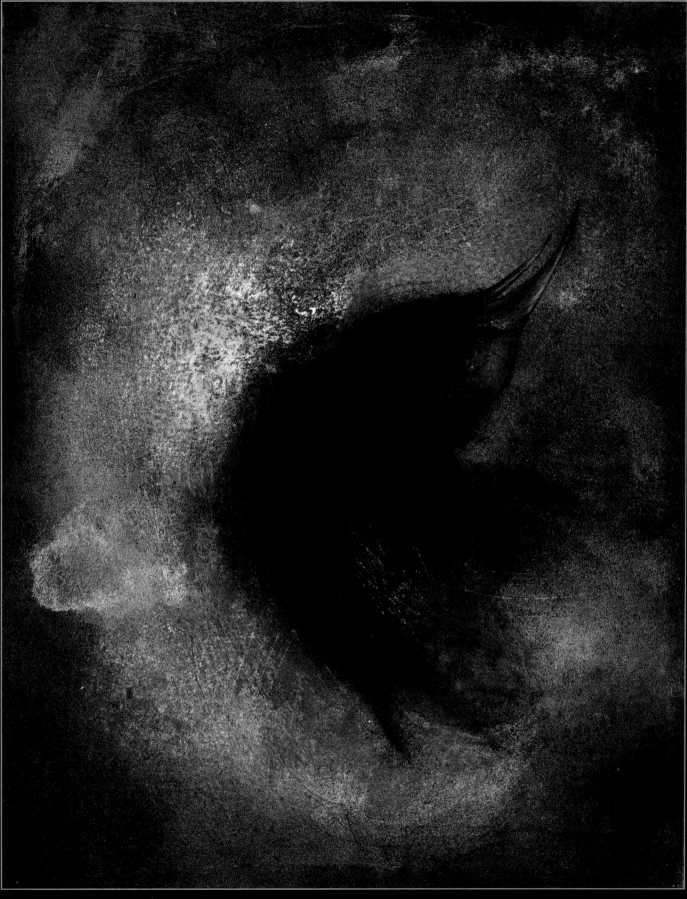

Study for Self-Portrait. *Mixed media on paper,* 14 x 11″ 2005

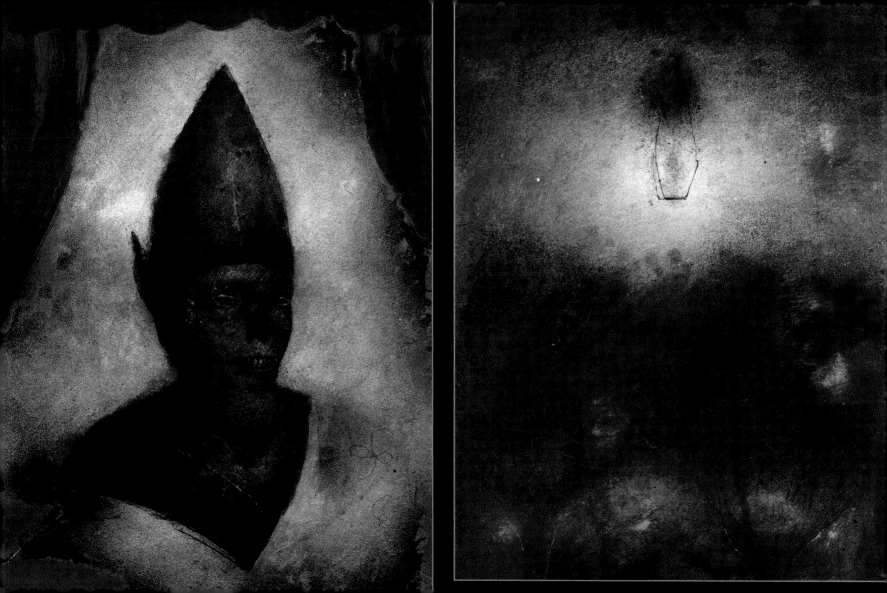

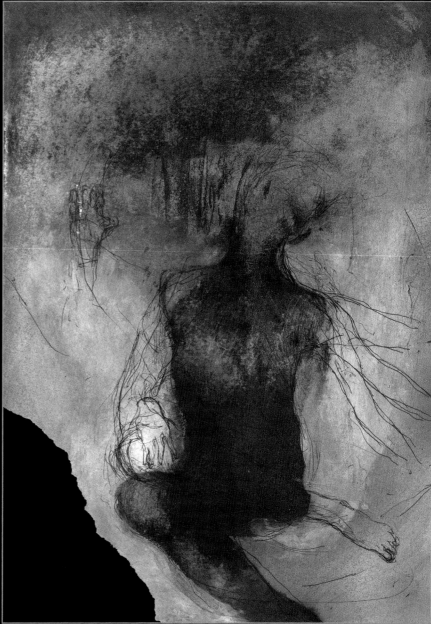

STUDY FOR WILTING WOMAN. *Mixed media on paper*, 12 x 9″ 2000-2006

STUDY FOR FIGURE WITH SAD AND HORRIBLE AILMENT.
Charcoal, ink, acrylic on paper, 10 x 8″ 2000-2006

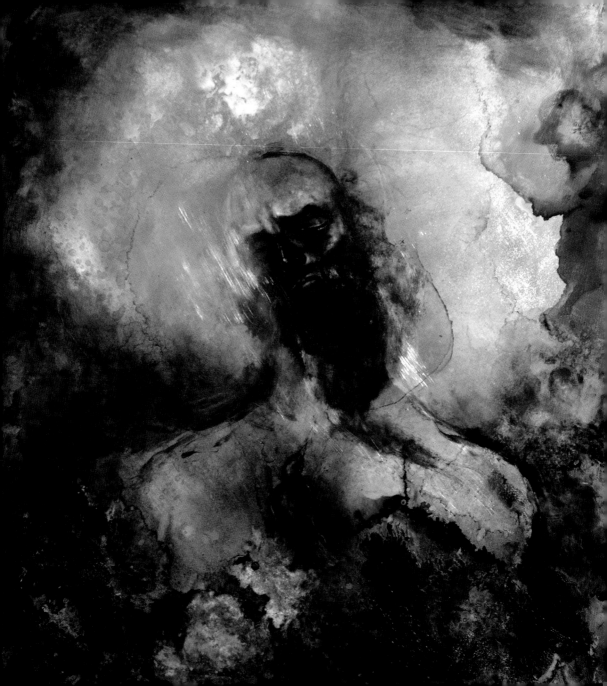

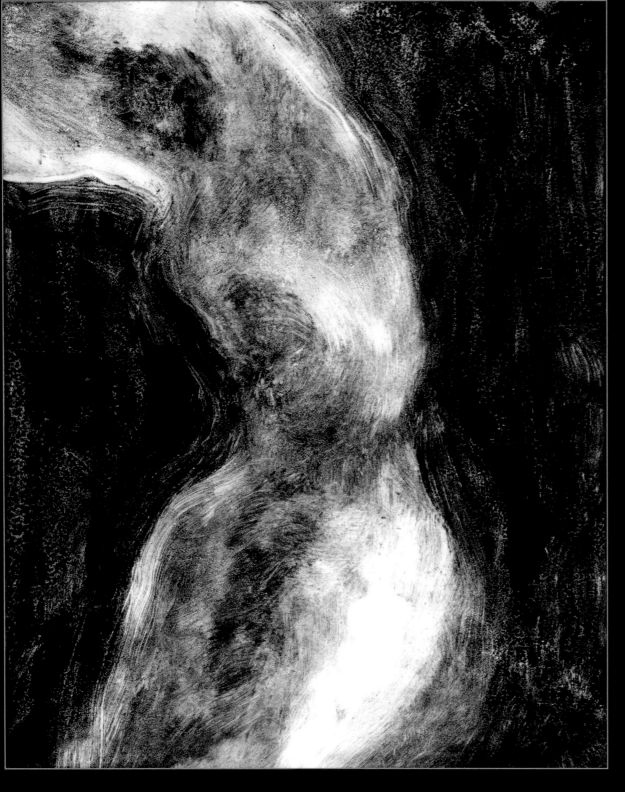
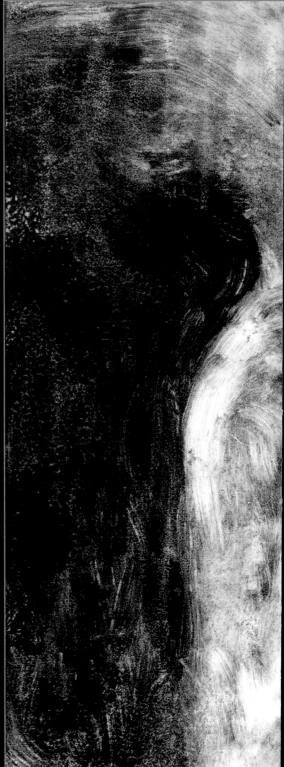

EMERGING GHOSTS I, II, III. *Monoprint,* 10 x 8″ *each* 2006

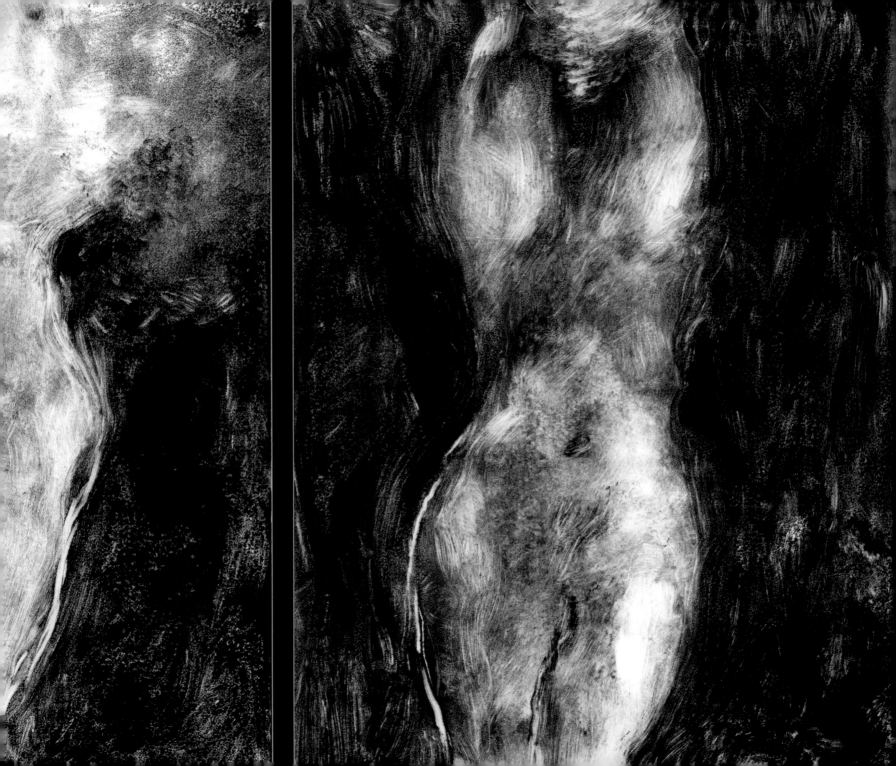

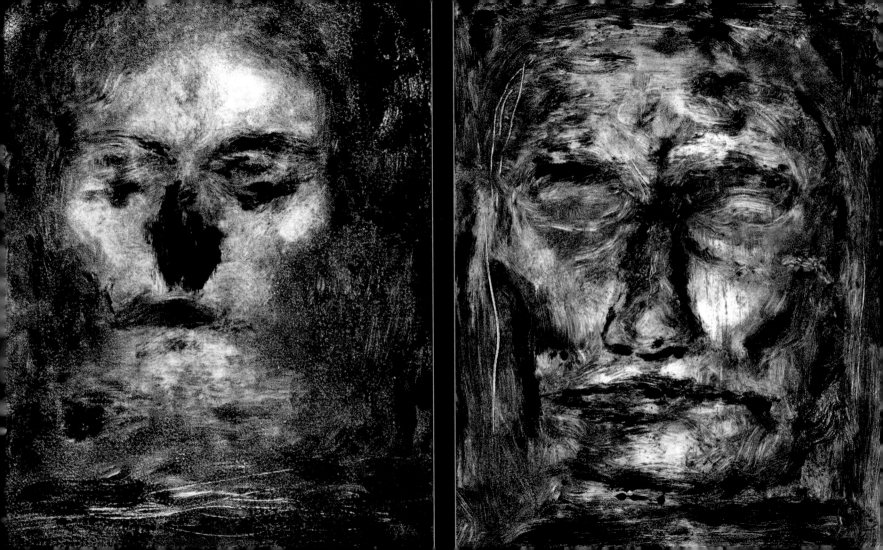

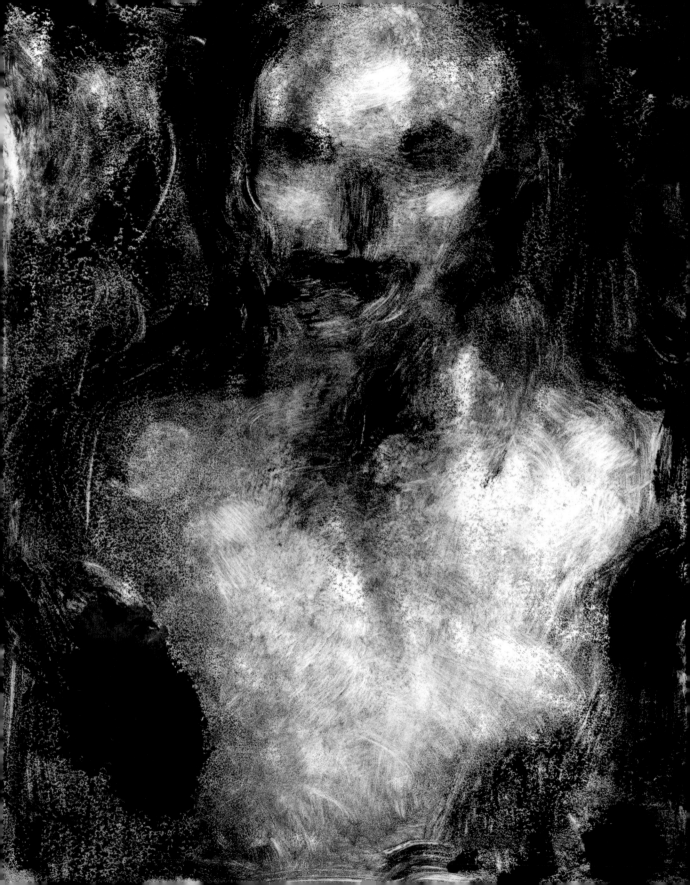

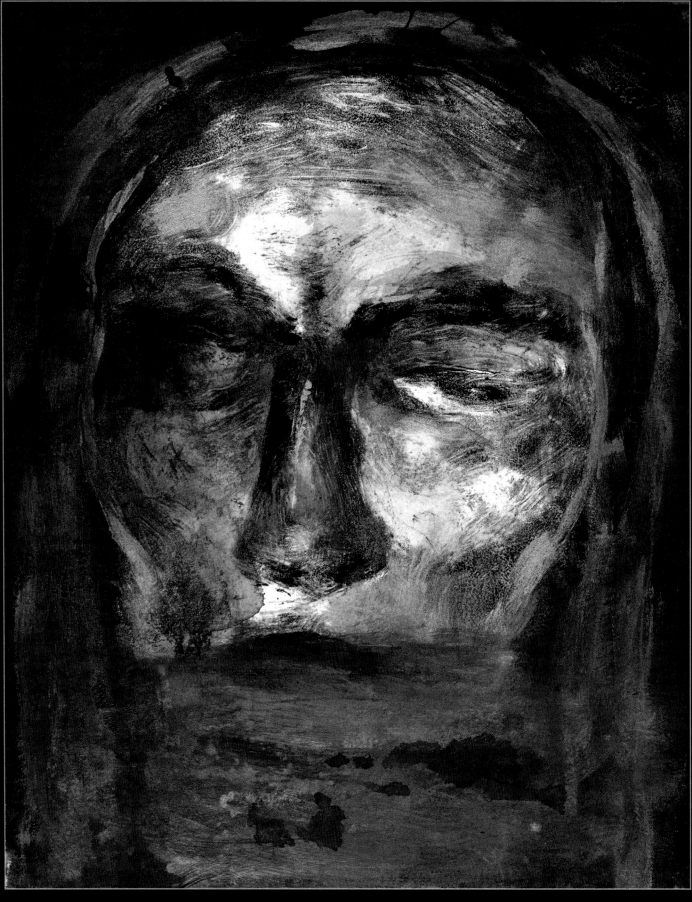

UNTITLED. *Monoprint reworked with ink and oil,* 10 x 8″ 2006

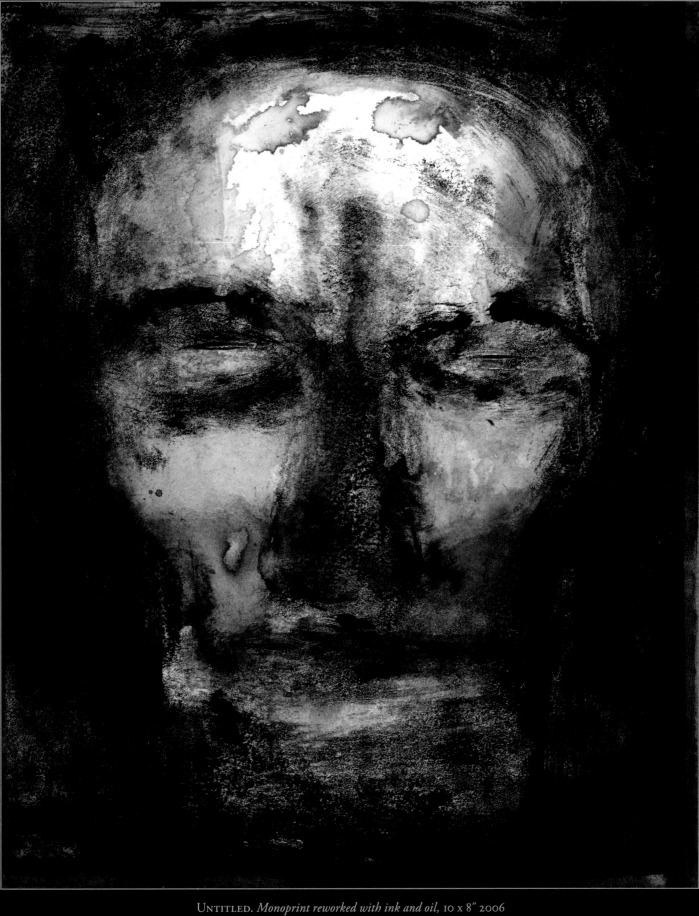

UNTITLED. *Monoprint reworked with ink and oil,* 10 x 8" 2006

Rarely do I use reference for painting. I try not to look at photographs, as I prefer to be unconsciously influenced by images and ideas, after they have already been absorbed.

But this is the very purpose of my photography- I use the camera less to sketch out ideas, and often less as a means to produce fine art, but attempt to utilize it as a method to capture emotional states as they occur in real life, which can then translate into memory and painted image. In this, I mean that I don't usually set up shots in an attempt to prefabricate an emotional state. Nor do I try to hide my use of the camera from the subject. If I am shooting a portrait, I will extend the session over a period of time, with large breaks in between photographs, or I will take only a few very quickly, and sometimes only one. These decisions are circumstantial, and vary from time to place and person and reason.

The idea is to attempt to accurately steal a moment in time, so that I may recall the emotional qualities of those moments very

readily. I can absorb the images, then leave them, and take the memories with me to painting.

When I photograph, I am not always so concerned with capturing pristine, crisp images, typical in photography. Often, I intentionally pay little attention to my camera settings, and will even manually adjust my settings, having only a general notion of what will happen in print. There may be two reasons for this- first is the emotional element; attempting to use the camera as an extension of real life experience, and so doing, I try to organically manipulate the camera to my will. The second is my deep admiration of early and Pre-Raphaelite photography. How I wish I had their tools. I have seen little else that can compare with the glorious, lush crudeness of Daguerreotype portraiture, 19th century memorial and *spirit* photography. My photographic images tend to pay homage to this early history in photography, without attempting to directly mimic it.

More so, the intent of my photography is to bring images to life fluidly and organically, as I do in painting. "Letting go" of strict, disciplined consciousness while painting produces a certain type of image, and likewise, utilizing the same kind of approach, a particular kind of photograph.

The strength should lie within the sincerity and concentration of the image, regardless of tools, regardless of medium, and if successful, regardless of logic.

PHOTOGRAPHY

UNTITLED. 1993

UNTITLED, 2002-2006

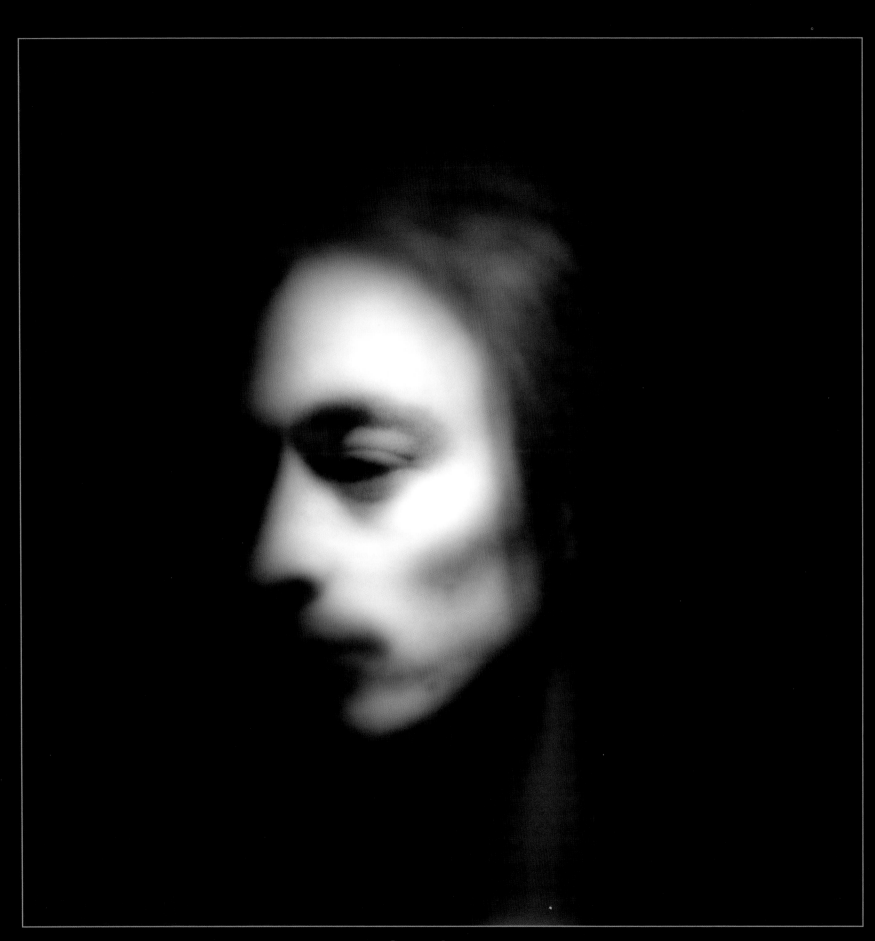

PARADISE LOST. 1993

MG. 1993

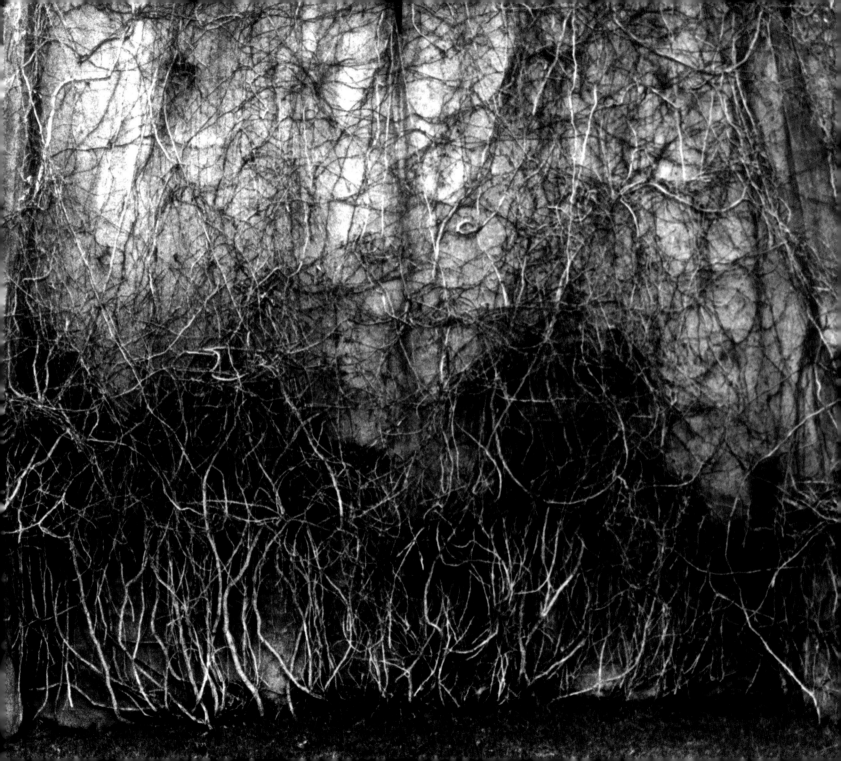

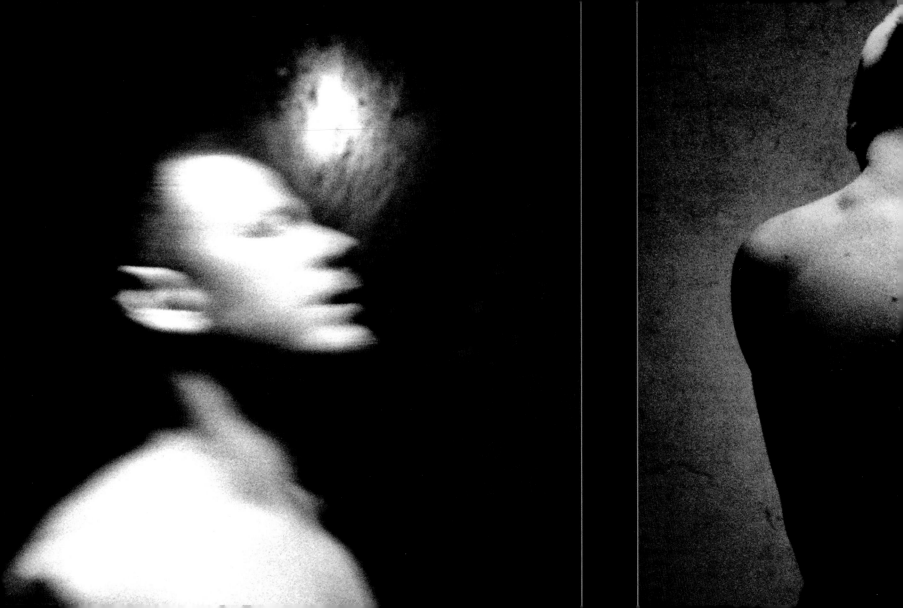

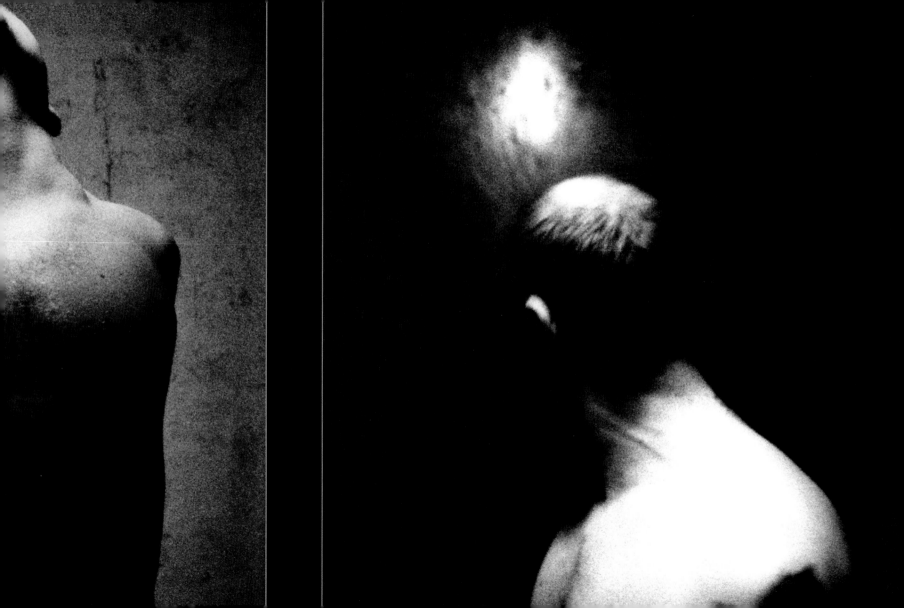

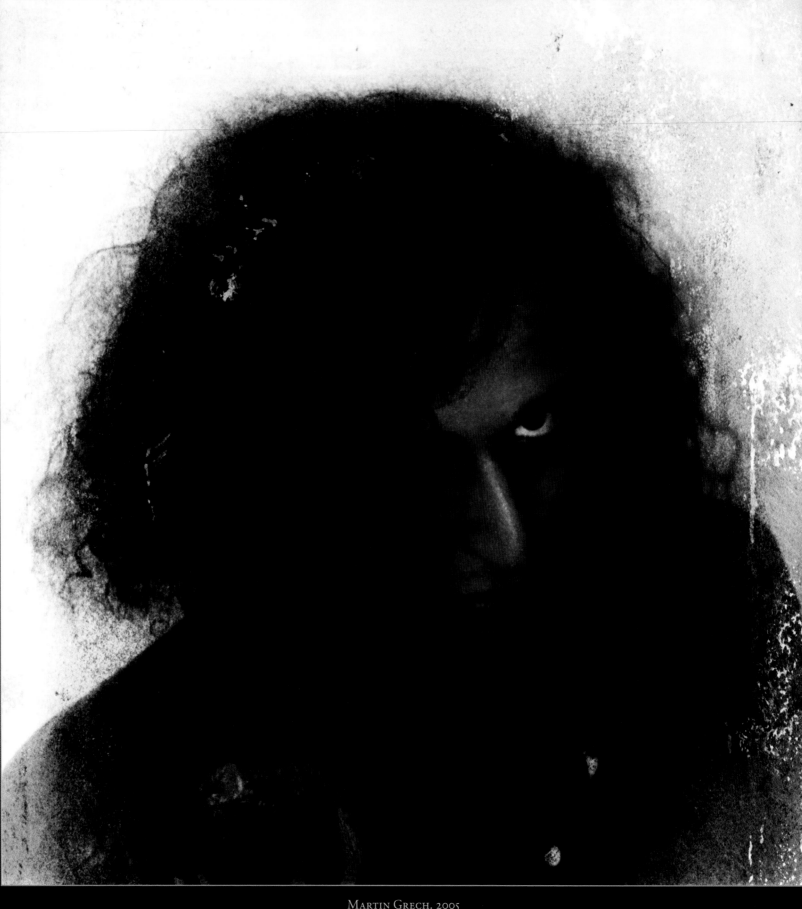

MARTIN GRECH, 2005

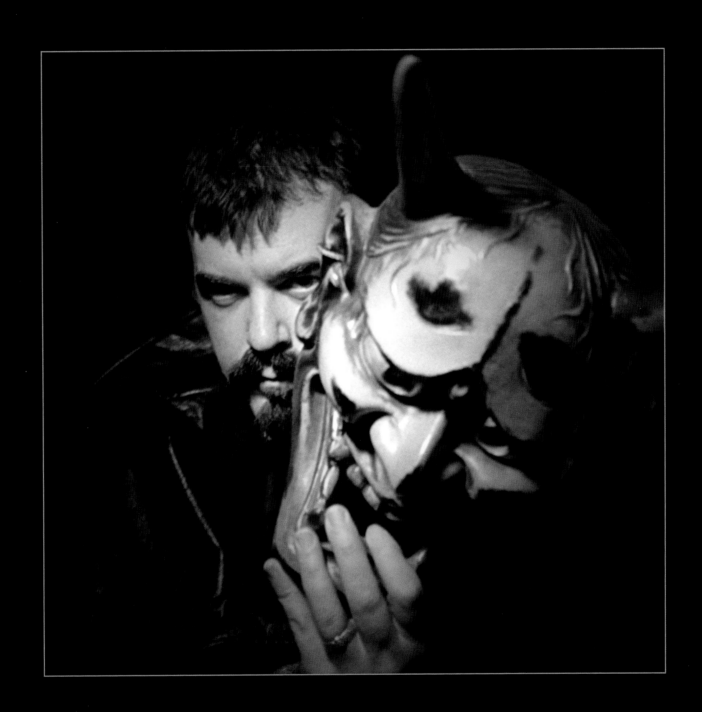

BOYD RICE. 1999

Sunn 0))) II. *Chicago*, 2004

Sunn 0))) I. *Chicago*, 2004

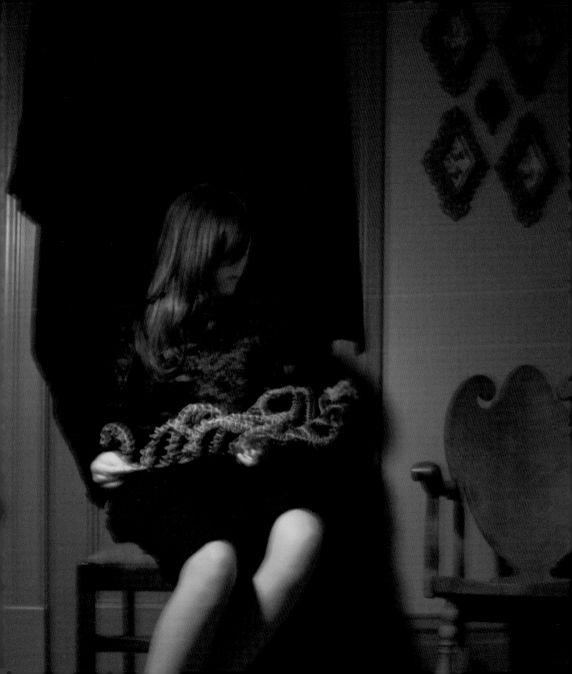

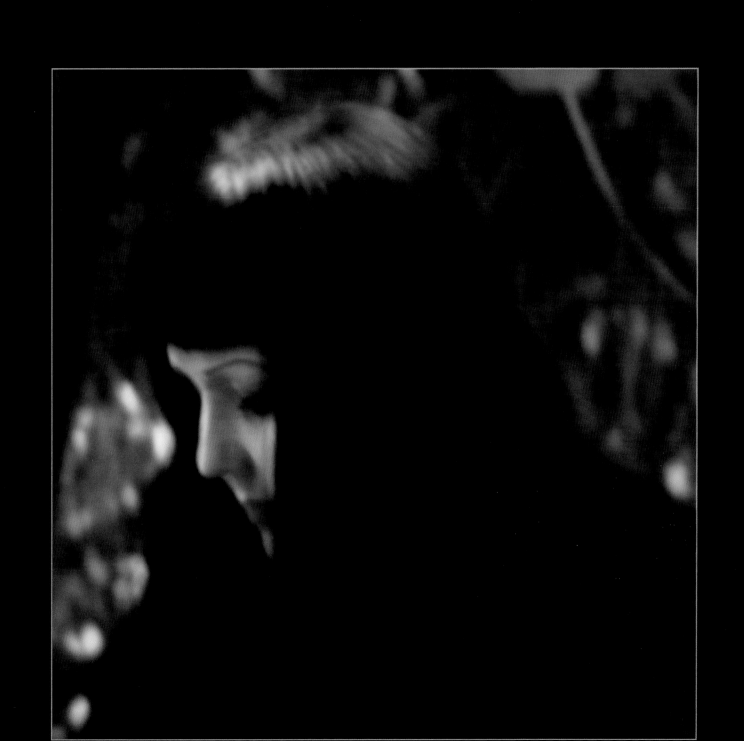

I have always been enchanted with the marriage between music and art. At a very young age, I took to heart the resonance that images on albums offered in expanding the musical experience itself. Raised in the 70's, I got to appreciate the vibrancy and explosive creativity of many then-contemporary rock albums, which later became historic, cherished classics, before the minimalism and primary color-dom of 80's LPs washed it all away. Needless to say, my interest in this genre was inspired by my intrinsic love of music, first and foremost, which I have had since I can remember. I always felt strong emotional bonds with various types of music, which motivated me to study guitar and drums for many years, and from an early age.

It is this love and connection with music and it's graphic history that has encouraged me to pursue the creation of images for various current groups, as well. It is a rare pleasure to be trusted with a group's recordings, who are confident in my ability to convey their ideas visually. Since I normally paint while listening to music, it becomes very natural to take inspiration from an album, with the intent to produce images dedicated to their various aspects and personalities. Often, it is best when I am not necessarily forced to premeditate ideas toward an LP. More often, the ideas become fluid in the process of repeated listening, and it is likely that my imagery will change with that flow to produce truly interpretive metaphors.

❦

There is a tremendous stigma in the art world against the 'commercial' production of album art, which seems awfully hypocritical to me. It is the interest of the artist to transform, to convey and communicate ideas, regardless of their origins. It is more important that the visual communication has a weight and integrity in what it is trying to do; it is the birth of ideas inspired by other ideas, continuously, on and on, in a striving Golden Ratio. Very little else has the relative emotional equivalent to art than music, and in this regard, the validity of 'album art' cannot be challenged. To me, there is very little difference between the integrity of painted set decorations for opera, or interpretive dance or ballet, and the honesty of thoughtful, well-executed, reaching album art and design. Simply, one lives briefly and on a different plane, another balanced in the quality of your personal album shelf. Yet the latter allows the listener/viewer to admire and become enveloped at will.

In this, I do not judge the music I treasure, but embrace it, often without question. That would be too much like judging one's own emotions. Music, like art, is a thing that transcends words and explanation. At it's finest; it is a purely emotional reaction to ideas, elemental and cosmic thoughts, unbound and roaming. It is essential sustenance for the dreamers, and when art and music are properly joined, far-reaching emotions become readily available, led by wide-eyed horses of rapture.

Khlyst. *Chaos is My Name*, 2006

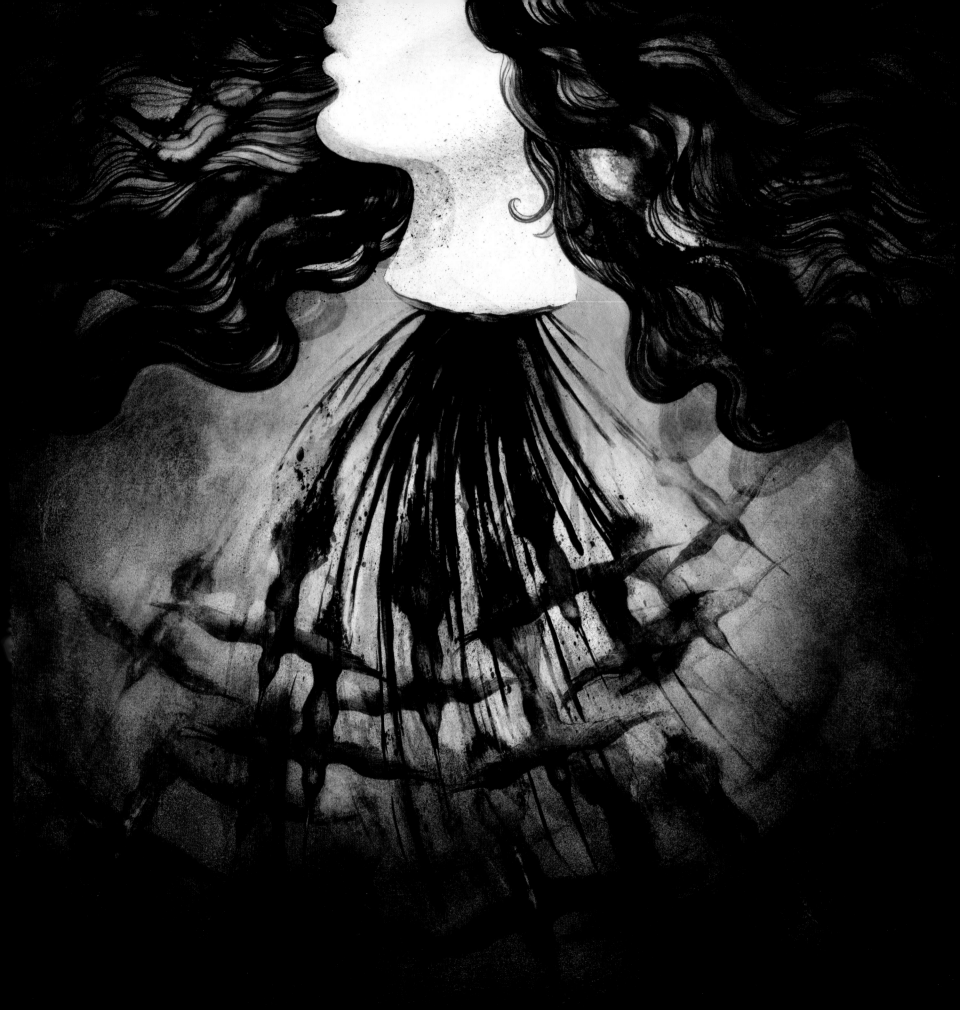

Khlyst. *Chaos is My Name*, 2006

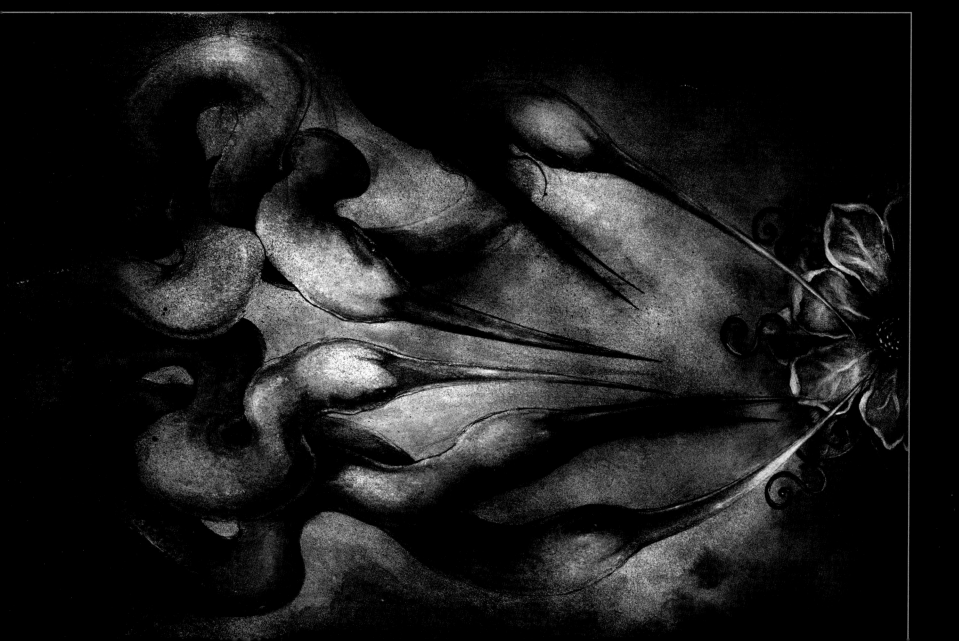

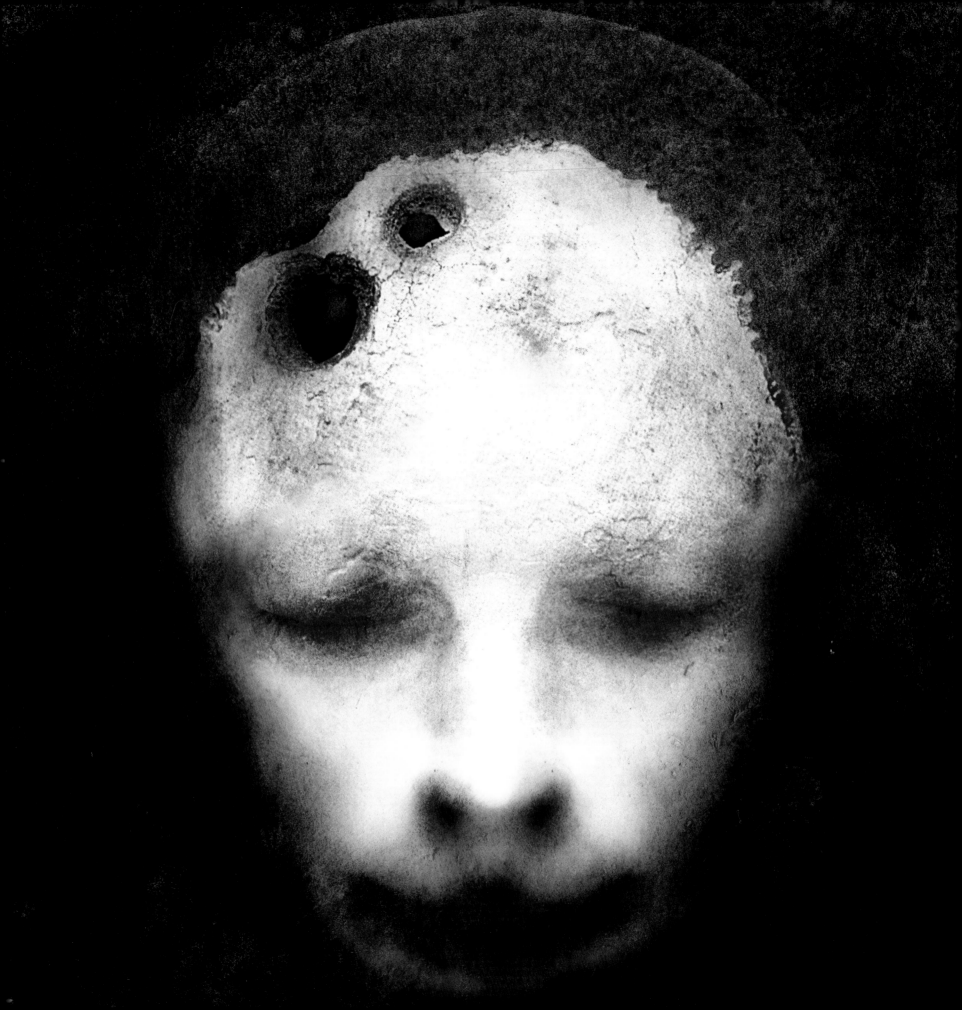

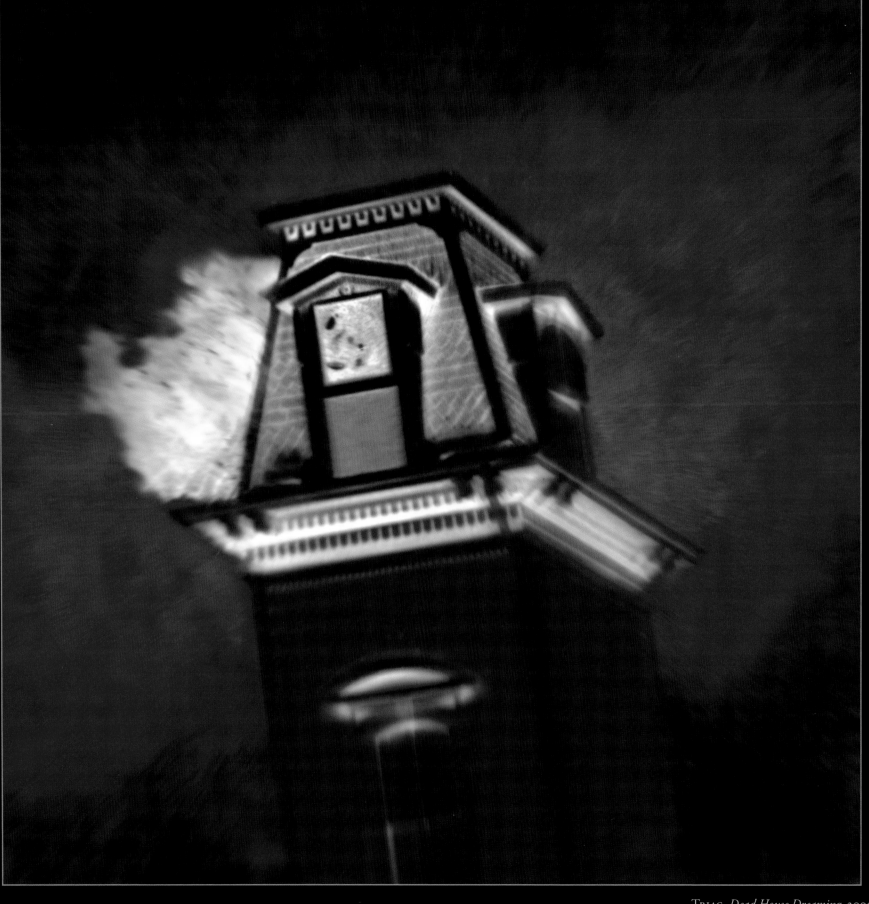

TRIAC. *Dead House Dreaming*, 2005

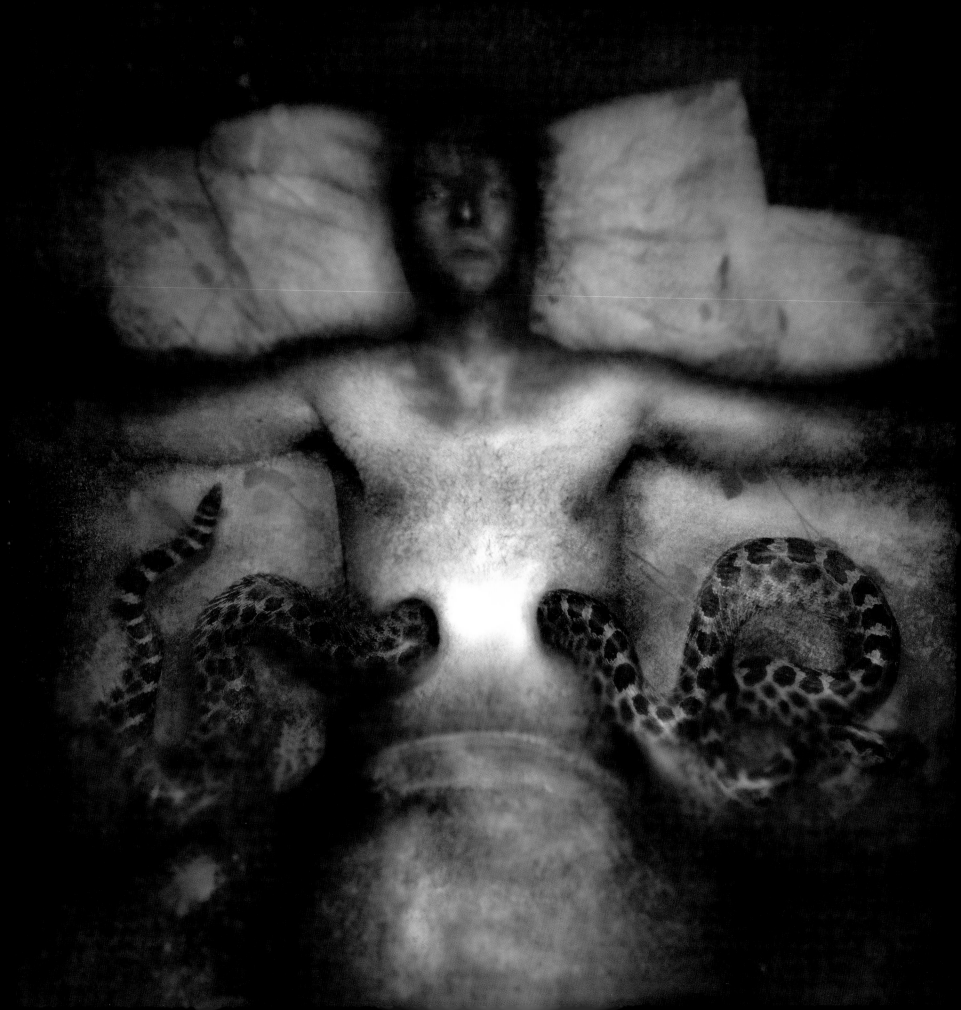

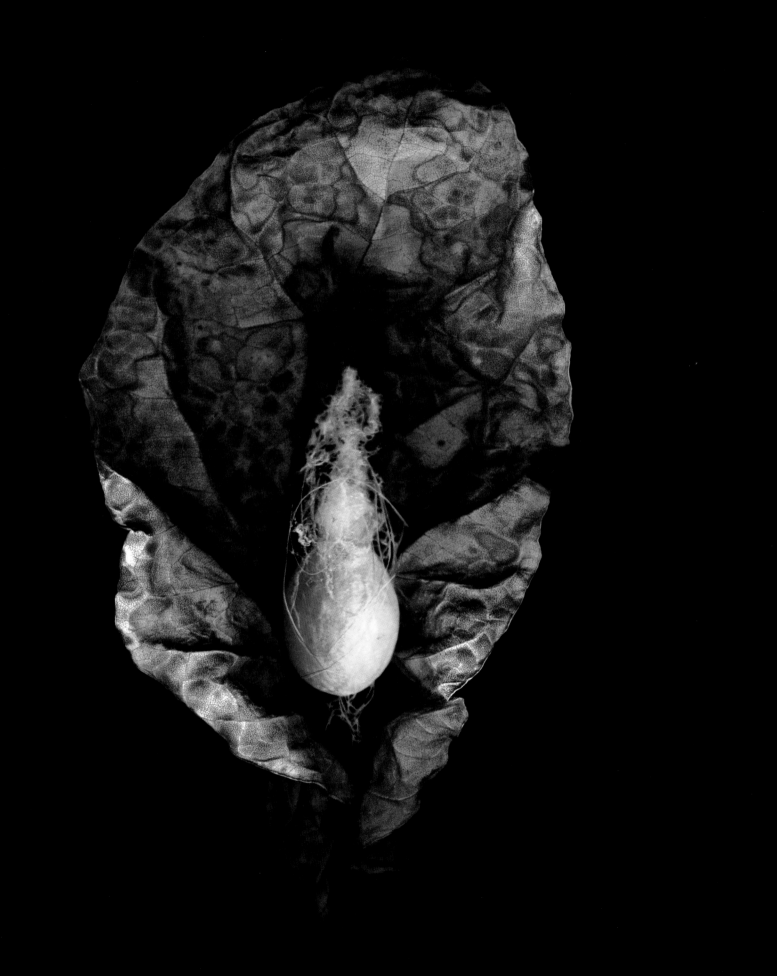

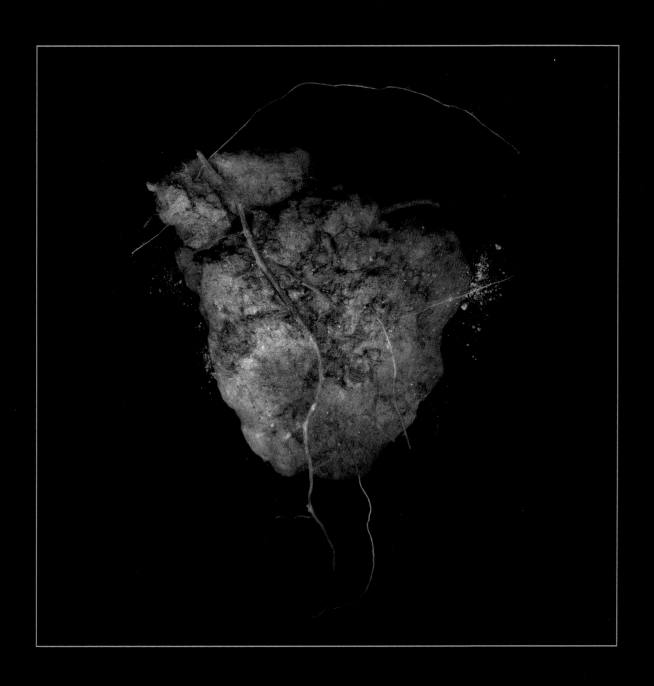

Darsombra. *Ecdysis*, 2005

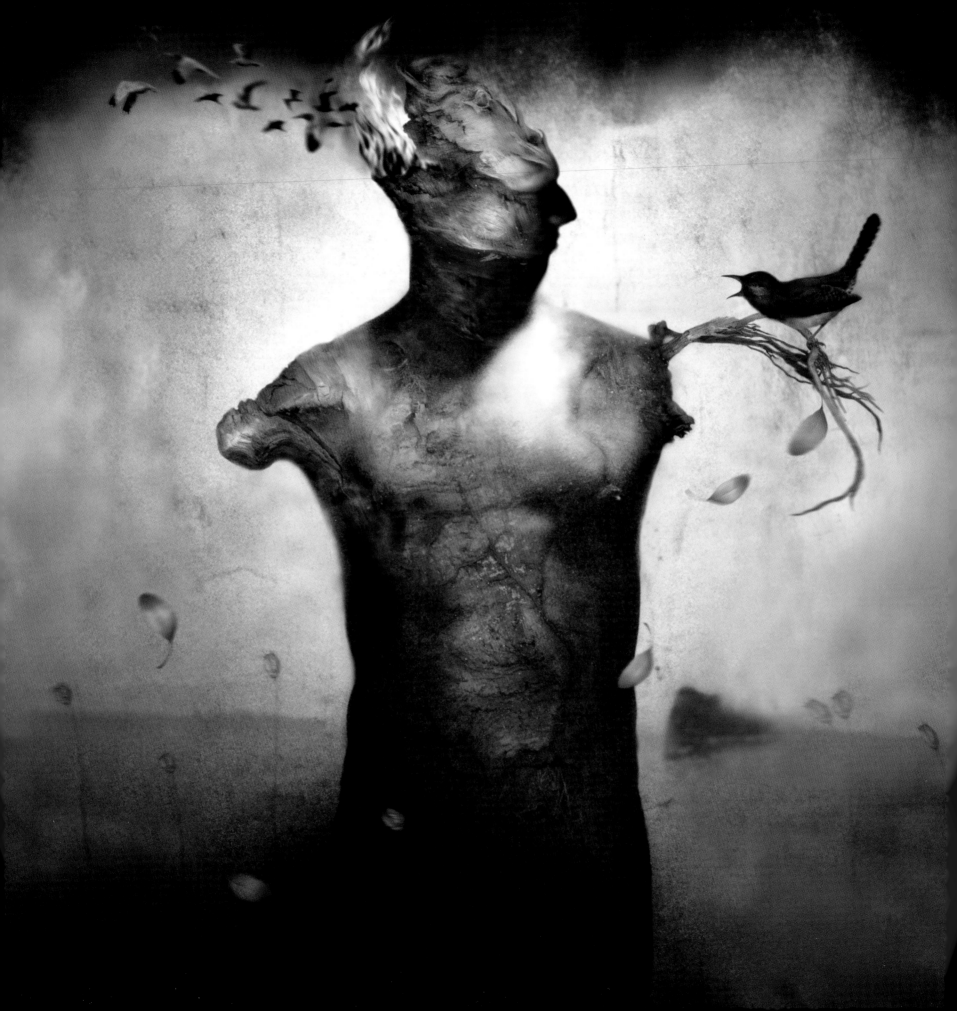

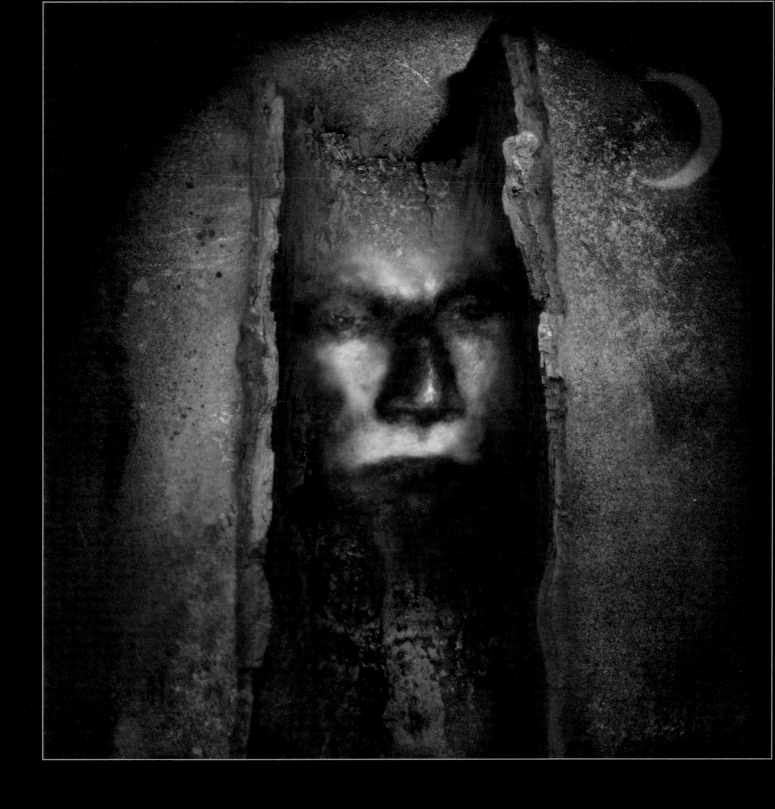

OF FIRE. *Ashes to Embers*, 2004

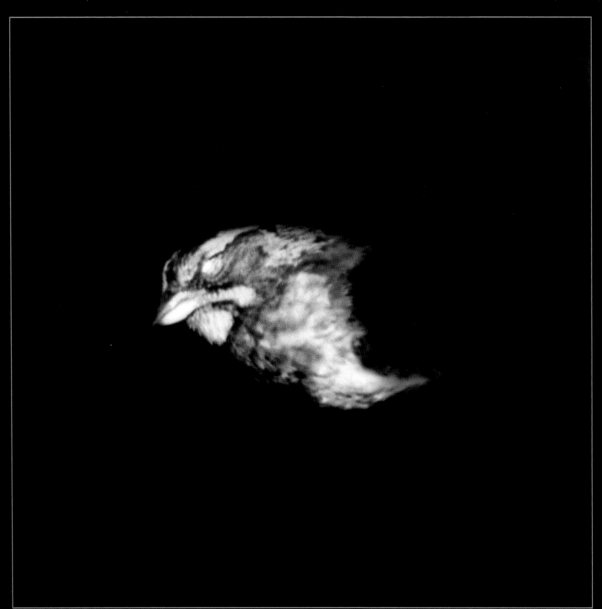

Ruhr Hunter. *Torn of This*, 2002

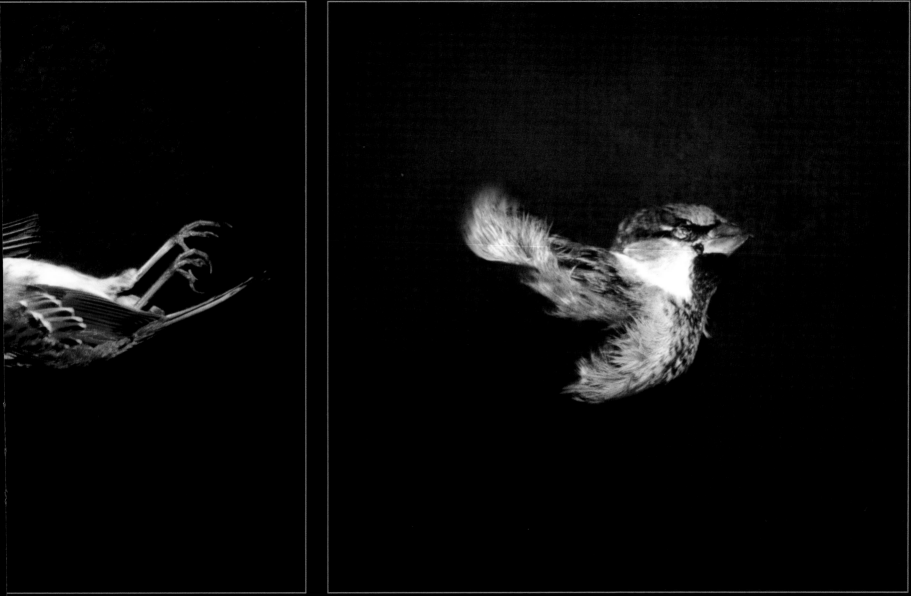

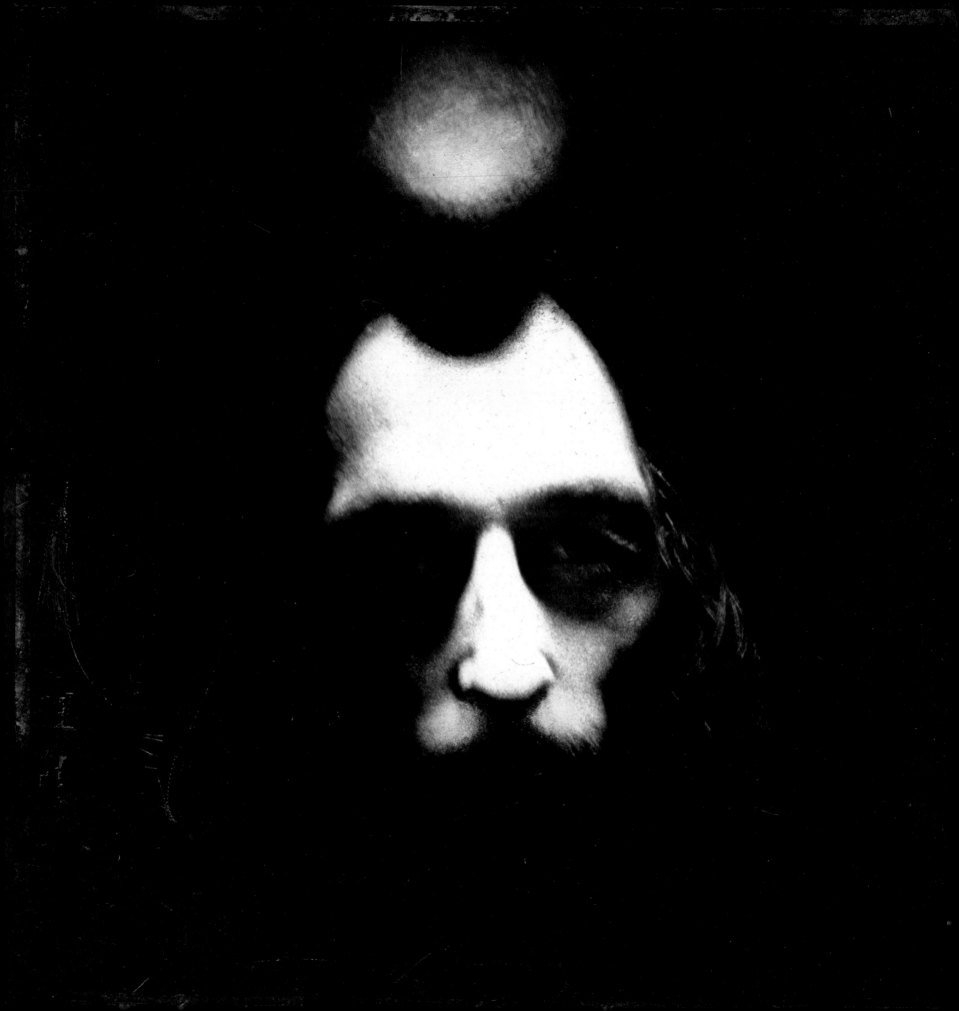

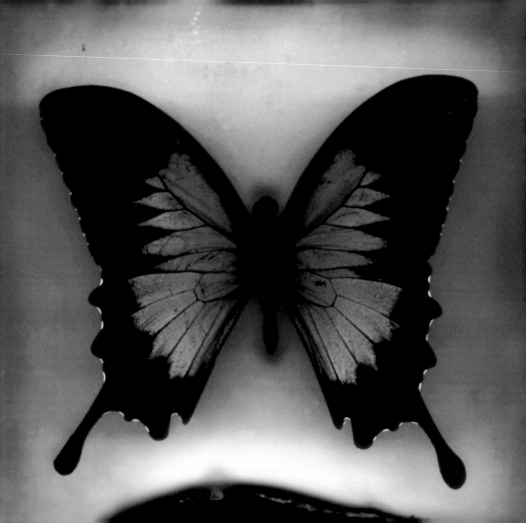

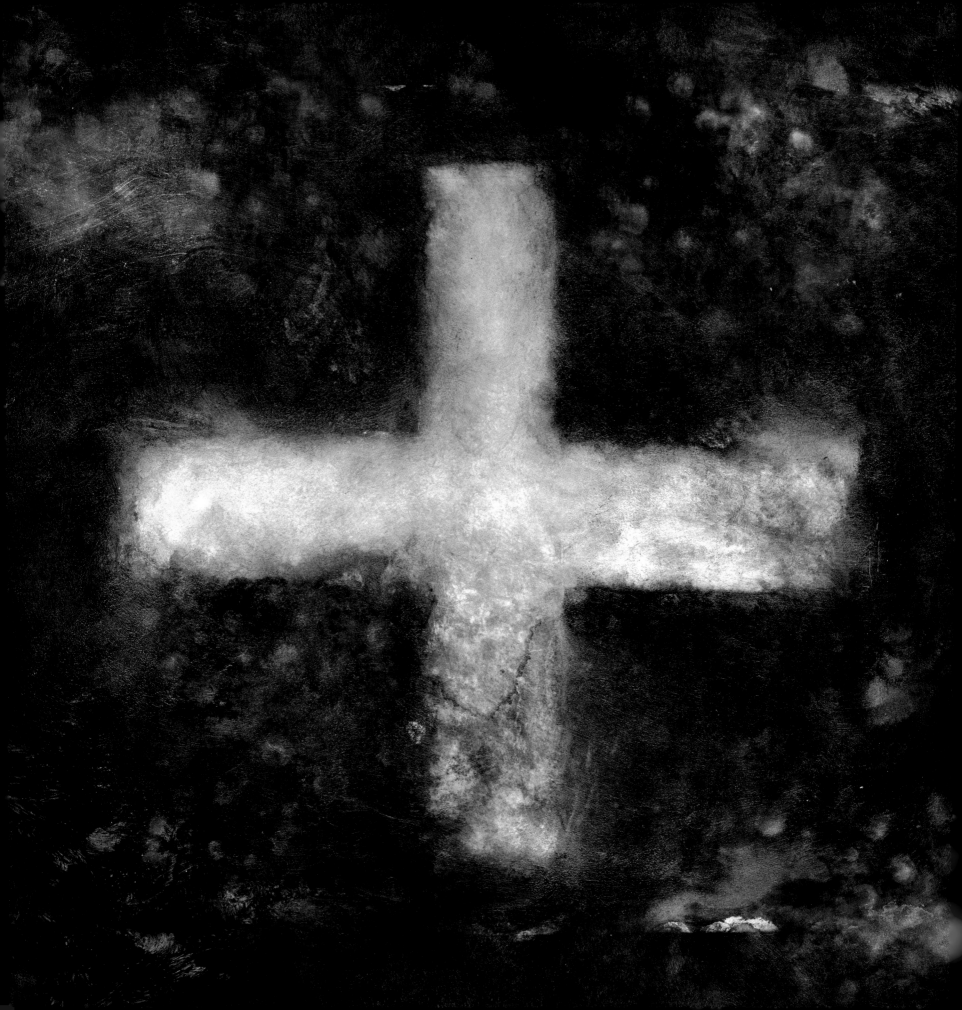

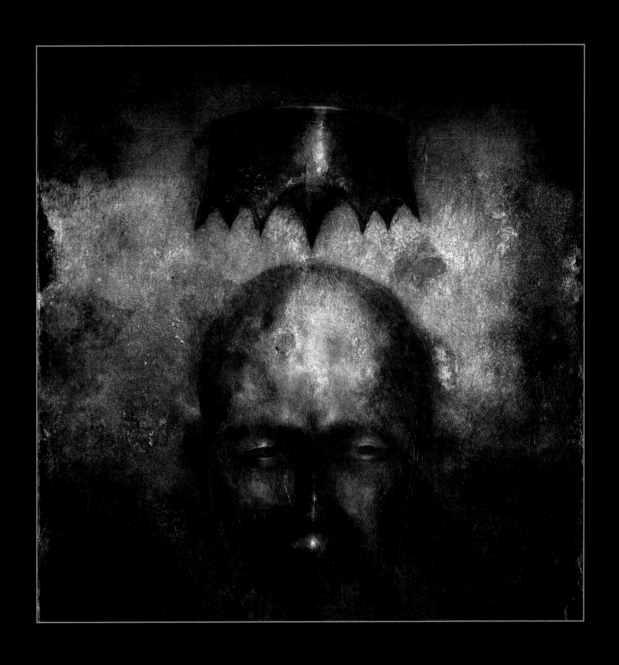

Martin Grech. *Unholy,* 2005

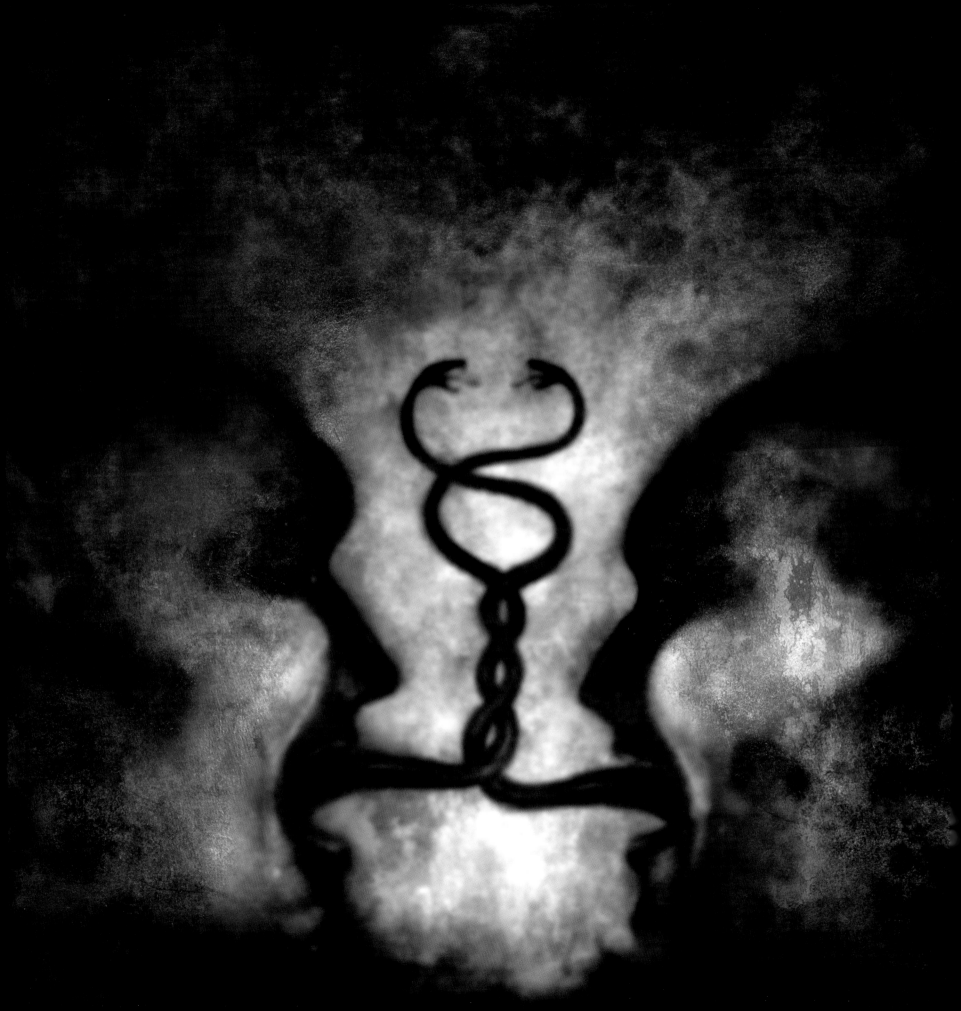

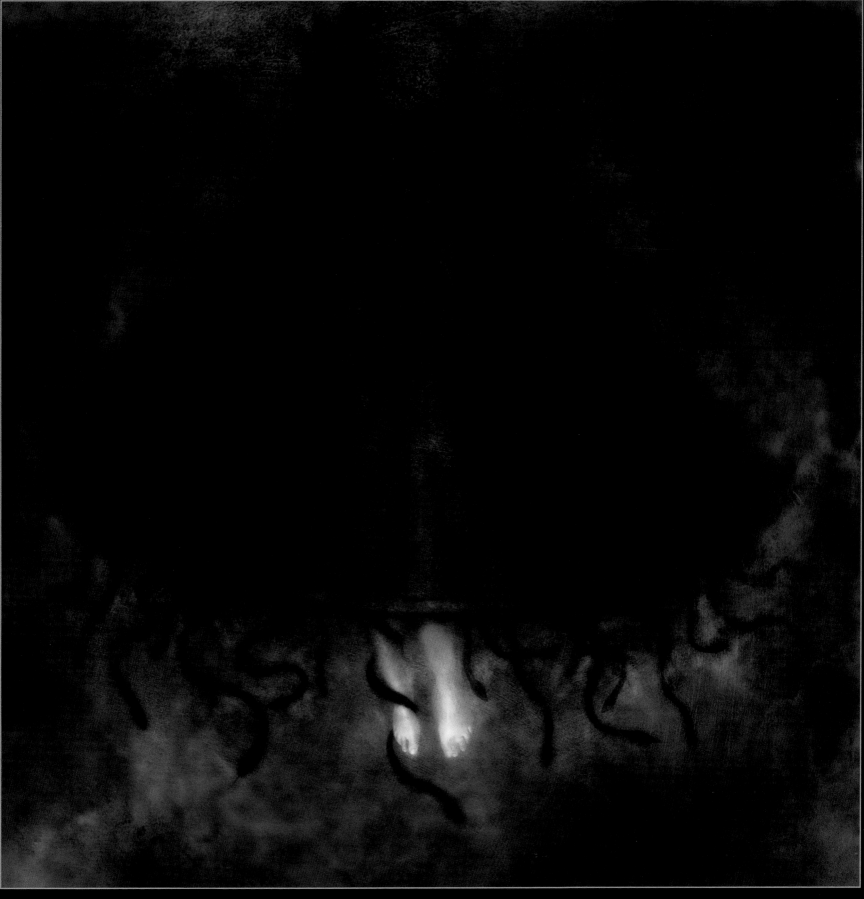

IMSA. *Hail Horror*, 2006

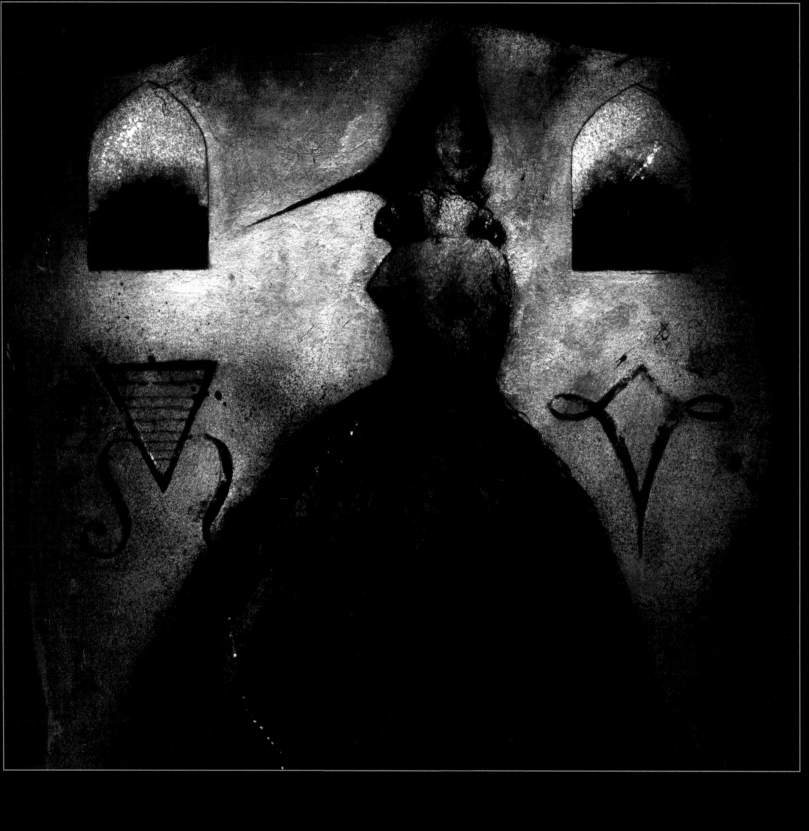

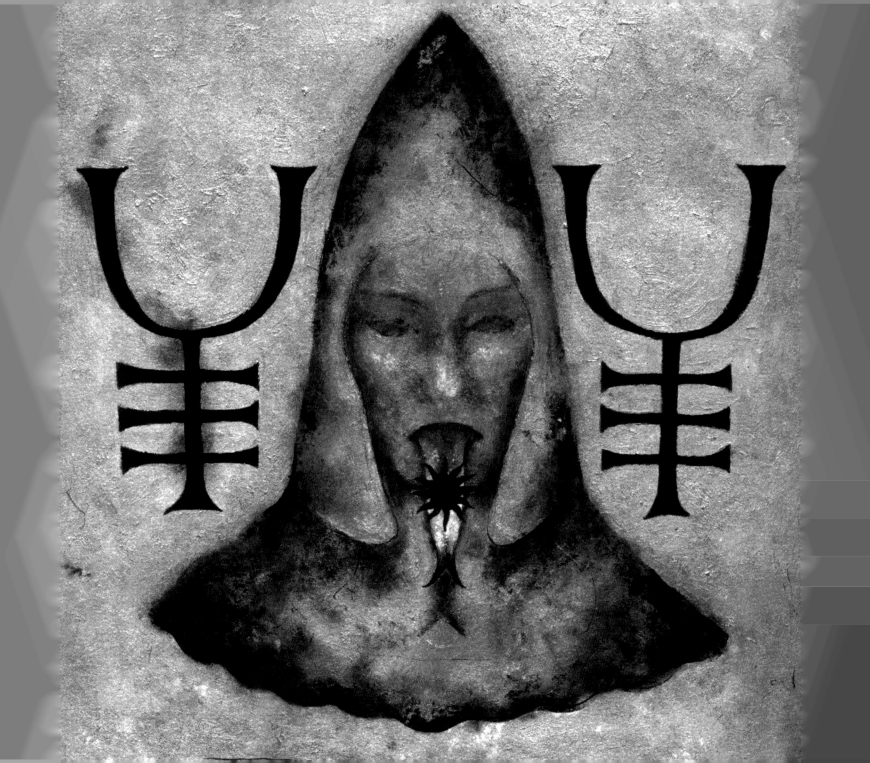

ON COLLABORATIONS
by Stephen Kasner

Early in 2006, while preparing for a split exhibition with David D'Andrea in San Francisco, we decided that we should attempt to produce a collaborative silkscreen poster to commemorate the event. For this, however, we decided to go about it in a rather unique way. Most collaborations begin with actual, physical pieces of artwork that go back and forth between the participants, each having the opportunity to view, think and study on the marks, textures, colors, images, and ideas of the other. David and I decided on *nothing* as a means of projecting our thoughts. Each of us worked on drawings that we *thought* the other would appreciate and communicate with, all the while never showing our work to one another until they were complete. Throughout the fog of this vague process, and once joining our pieces together to create the poster, we were both delighted with the outcome. Despite the variance in our attack styles, these two works folded together with a delicate and easy magic.

It was through this, and during our exhibition at SPACE Gallery, where we decided to continue our collaborative process. From here on in, however, we would create physical works handed back and forth to one another, in a more traditional manner.

I was so intrigued and excited about the possibilities of this process, I began to express the idea amongst several of my most cherished artist friends. Each one, all of whom I have both admired and been fortunate enough to know personally, met my collaboration idea with mutual excitement and gusto. It was beyond thrilling to continuously send and receive various pieces of art, for months on end, to and from such a wide variety of artistic masters. Again and again, they would come in with their own energy and persona, and I sent them back out with an attempt of capturing a sense of my own spirit. Lines began to become blurred at places. Each piece carried such individual strength and there were moments when I felt I was caring for a friend's child. It was beautiful.

There was one exception to the mailed collaboration system in this series. Steven Johnson Leyba and I caught the opportunity to actually sit *with* one another in the process of these collaborations. We spent several days enjoying each other's company, discussing the process and watching one another work. It was exhilarating, exciting, and a very different and unique way for me to work. I tended to concentrate on large washes of shape and form, while Leyba delicately attended to minute details, the likes of which I would have never conceived.

Every artist presented here brought new, stirring and personal challenges to these pieces, each with his own way of working; Seldon Hunt's meticulous, brooding lines, Steven Cerio's childlike, psychedelic freedom, David D'Andrea's apocalyptic visions and Steven Leyba's quests for perpetual enlightenment... I'm continuously honored to be a part of them all.

COLLABORATIONS

Things fall apart, the centre cannot hold,
Mere anarchy is loosed upon the world,
The blood-dim tide is loosed, and everywhere
The ceremony of innocence is drowned;
The best lack all convictions, while the worst
Are full of passionate intensity.
 (W.B. Yeats, *The Second Coming*)

I really felt that my world was falling apart and my heart was heavy from the bullshit factory of my culture, and it was seeping into my personal life. I needed to do something about it or at least bond with someone I trusted. I needed to see a fellow painter whom I admired and believed in. I know a lot of people that make art but I consider very few to be true artists. Stephen Kasner is true. He is a true artist and a damn good painter. He speaks the truth and doesn't play the game and it shows in his work.

It was the 4th of July weekend of the summer of 2006 and I was leaving San Francisco for good, but first I was off to visit Stephen and Rebecca. It was quite a harrowing time for me, with much chaos all around. Friends and lovers were suddenly turning into vicious enemies. The end was near for many things in my life. I was in a bad space and needed to get away and relax before my great escape from the concrete curtain of America. I was moving to Europe to flee the contrived consumer warfare Hells of our great country. I needed to get away from the paranoia, the compulsory desire and the entertain-mental control. Stephen and Rebecca Kasner offered me a sanctuary before my great exodus.

Stephen also needed to take a break because he was facing some fierce deadlines for paintings for this book as well as other projects. He had done some work on several collaboration paintings I had started. We both paint layers over layers of oil and acrylics. Our techniques are compatible, our approach similar, our subject matter both figurative but the final outcome is quite different. My work can be quite literal, physical, photo based, dismembered, pornographic, of this world, political and Freudian with bright colors. Kasner's paintings seem to me internal, lyrical, whole, archetypal, Jungian, emotional; sensual with dark hues, but both of our work is quite personal. Often times the artist's personality overwhelms and distorts the art. You see cult of personality but you don't see much of the personal in modern art, just agendas. Kasner does not confuse himself with his art. His work has ambiguity yet it is always human. His work is timeless; it could have been painted in the 15th century or five thousand years in the future. He is an American, first generation Croatian American, but you would not know that from his work. If there is any hint at Americanism implied in his art it is that of Henry David Thoreau's *Walden*, of Jack London's *Call of the Wild*, or of Walt Whitman's *Leaves of Grass*. He praises the natural world just as William Turner did. Like Turner, his paintings are almost abstractions. Also like Turner, his paintings are about the human experience. They are impressions, feelings, and yearnings or perhaps pause. One feels there is some sort of great

contemplation taking place before some sort of impending physical or mental destruction or breakthrough. I have seen people at his exhibitions stare into his work long and hard. They stare as if they are looking into a mirror or as if they are hypnotized. It is almost as if they are in meditation. I like to think of it as a spell he has cast. In fact, it is because some of his work is a personal invocation and spell, which means there is much pre-Christian ritual magic being created. The art critic Robert Hughes once made the observation that as religious a country as America is, there were almost no good examples of contemporary religious art. He obviously has not seen a Kasner. The work is devotional and it is religious but it is religion without a hint of dogma. There are no instructions; you are on your own. It is the spirit of human struggle that he depicts. It is the triumph of the human spirit where every cell in you struggles to find and keep personal freedom. His art is religious yet defiant. Every Kasner canvas seems to me very Kali-esque. Kali is the feminine destroyer

of masculinity. I would argue that he may be using the human figure as a metaphor for the feminine destruction of the masculine control systems of western civilization that seeks to quantify and contain all personal thought and spirituality. I look at a Kasner original and see a manifestation of Kali Yuga. I see in his work the fourth and final stage of the four stages the world goes through in Hinduism, yet he is not Hindu. Kasner's art is above and beyond the rules and laws of this world's religions, flags, countries and movements in art. We are collectively being destroyed and we know it but we also know all this is a learning experience that can make us stronger if we fight it. As the quality of life and position America has in the world declines he seems to be telling us to look to our own instinct to survive the degeneration because we are bigger and better than the traps of languages, cultures and republics.

Kasner's work is sometimes the beautiful colors and textures of a diseased body and soul, yet he is no doomsayer. He

is not painting the end of all things, there is always a transformation taking place. There is always a doorway out. It is the depiction of entropy. It is nature. He embraces nature; including human nature. He refrains from all moralizing of the silly dichotomy of what's good and what's evil.

His work is the peaceful melancholy of impending violence. As a fellow American, I have always felt this impending violence inherent in the culture. It is the feeling you get if you know something quite horrible is going to happen to you but perhaps it never will. Living in a country obsessed with violence, it doesn't matter if the violence never manifests, because the feeling you get is its own form of violence. He may very well be a modern Goya, documenting our inquisitions and our social collapse. While we are busy asking ourselves what Paris Hilton is doing, Kasner is planning our escape. I think he is telling us that there is a way out of our material obsession as global consumer citizens. He is telling us that the entire external world

s a fraud and that our inner reality is the only true reality. The only things that are real are the things we personally experience. He hints at the potential breakthroughs in Quantum Physics and our triumph over physical reality. There is no ego worship or artist megalomania here. Kasner doesn't even sign his paintings as most painters do. Rather, he signs the back because he knows that it is the art that is most important- not the artist. He is not interested in being a celebrity if that means compromising his vision. His work is a continuation of serious painting. Serious painting is concerned with human evolution, exploration and most importantly, truth. It is truth that a true painter seeks; they seek a personal truth that is a universal truth and that truth is ever changing and elusive. Just as soon as you paint the truth, it changes. While modern art is slipping out of the shackles of Post-Modernism and back to the human and figurative art, Kasner remains a step ahead of the rest. He is a master not only of the paint brush, but also of the computer

we never know where the paintbrush ends and the digital begins or if he simply painted it by rubbing in the pigments with his hands and then wiping away some of the paint with a rag. You can get lost in his work because you never get distracted by how he does it. It's about his subject and message not about how it is done. It isn't about the process, it's about the emanation of life itself. It is a form of Animism; we are all connected by life to everything that is living. He knows that the modern world is a world designed to take us so far away from ourselves we no longer know who we are. He is at war with those people and things that tell us who we are and what we want. In a Kasner you see the colors of Rembrandt van Ryn and of Jan Vermeer taken down in value on the grey scale. You can see the elegance of the Symbolists like Gustave Moreau, but also the sinister iniquities of Alfred Kubin, Arnold Böcklin and of Kupka. We never know if it is a nightmare or dream or reality. It is all of those things. You also see a few similarities to Swiss artist, H.R. Giger.

Much of Giger's work is monochromatic. Kasner's work seems monochromatic, but a second glance proves that he uses many colors, but they are muted, mixed on canvas till they are almost black. There are rarely any depictions of the mechanical, man-made world that you see in a Giger painting, however. Kasner's work is not biomechanical, but more nanotechnological. Perhaps the figures he paints have been altered on a molecular level, though they remain *human*. You also see in his work the anarchy of pioneer maverick Jackson Pollock and the philosophical defiance of Max Ernst. You feel the empathy of Picasso's *Guernica*; yet Kasner's work is something new and of our time. When you look at a painting by Stephen Kasner forget about being entertained, forget about the shiny glossy cool California kitsch paintings they are trying to sell you. Forget about the instructions of conceptual art and the atheism of minimalism. Forget for a moment what they are telling you, about what's cool and hip, and feel Kasner's art. Forget about the past and envision the

Steven Johnson Leyba is a Native American painter, a writer, a musician, an activist and a performance artist. He has been exploring human sexuality with his art all of his life and exclusively for eighteen years. Leyba has adopted the neologism "Sexpressionism" to describe his painting, a term coined by an art critic. Leyba works primarily in hand made books. He has created eight hand made books and is currently working on his ninth, "Sexual Deification and Spiritual Defiance". He is also writing a memoir about his life as an artist which will be called "The Last American Painter: My life as ART, as SEX, as RELGION, as WAR." Leyba is the author of the book "COYOTE SATAN AMERICA: The Unspeakable Life and Art of Reverend Steven Johnson Leyba", several spoken word CD's with his band U.S.A.F and the subject of Marc Rokoff's documentary "Unspeakable". He has exhibited and is collected all over the world.

STEPHEN KASNER AND STEVEN LEYBA.
California, 2006

future - your future. Keep in mind that the Impressionists were not fully embraced in their time. He may not be one of the art world's sanctioned artist's, but he may very well be one of America's last good painters, and one of the first good painters of the 21st century. Don't think of the art of Stephen Kasner as mere paint on a canvas or product or entertainment. Think of his art as a loving, feeling, living, breathing, thinking entity of enlightenment.

಄

I thanked Rebecca and Stephen for a magical time and I left them feeling I had the strength to continue fighting the never ending battle to discover and keep the truth.
 Hoka Hey!

Summer 2006,
Mercury in retrograde,
Somewhere in Fortress Europe
Steven Johnson Leyba

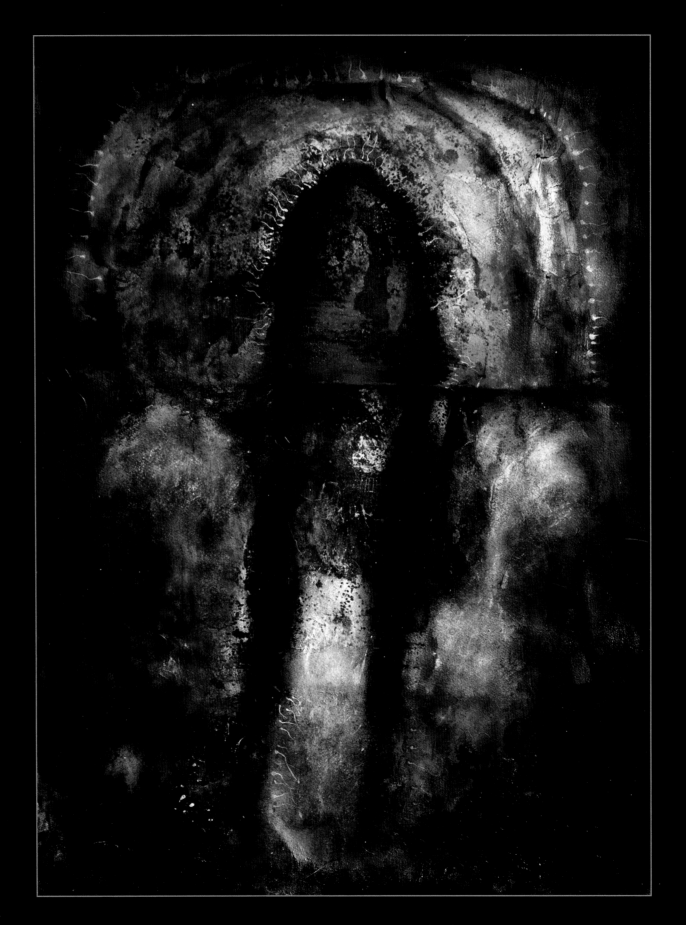

STEPHEN KASNER AND STEVEN JOHNSON LEYBA - SHAMAN I. *Mixed media on paper*, 29.5 x 22″ 2006

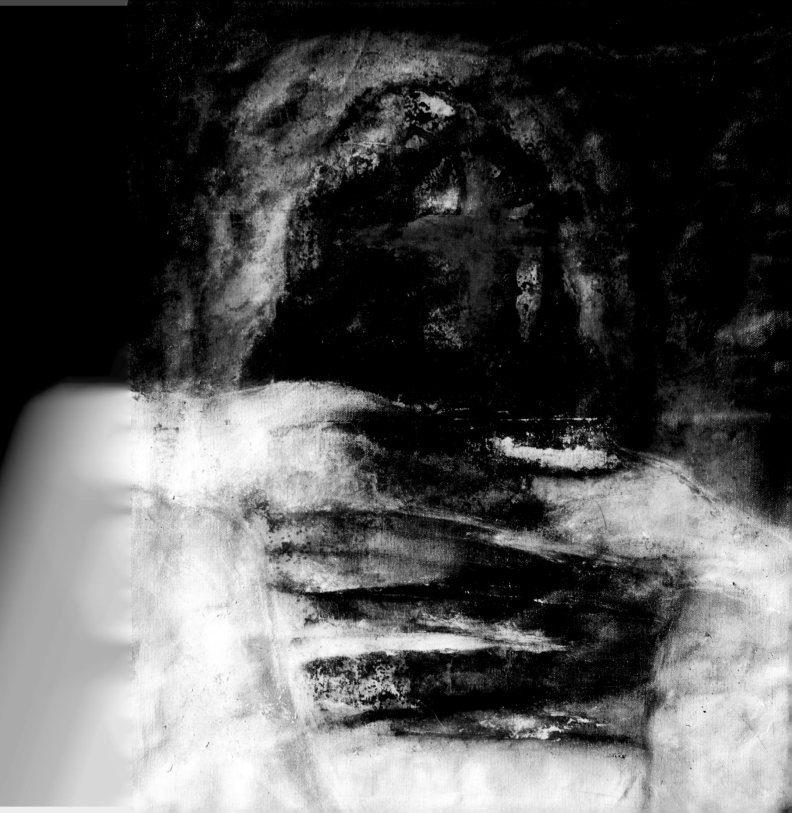

David V. D'Andrea believes in the tradition of the "memento mori", the visual reminder of the transience of life on this earth. Through signs and symbols such as aviform in flight, sigillary calligraphy, disembodied wings, and skeletal forms, he seeks to perpetuate the avowal that is death, and in turn catharsis; to create archaic crests for modern battles of loss, love, and hopeless abandon. David is currently working as a freelance illustrator in Portland, Oregon.

STEPHEN KASNER AND DAVID D'ANDREA.
San Francisco, 2006

THE MUTED REGIONS
by David V. D'Andrea

Stephen Kasner's work invokes the great Symbolist spirit. It is a burning vestige to ignite an aesthetic resurgence, an opposition to the limited reality of this modern age. It is a low blue flame to illuminate the muted regions of the soul.

Kasner is a link in the bloodline of past artists such as Felicien Rops, A.O. Spare, and Jean Delville. These artists drew from the wellspring of man's knowledge of the occult and esoteric, and recognized the dark spirit of all beings. They traveled to the realms of the aphotic unknown and reported back to the canvas.

If my work succeeds as a simple reminder of the hidden realm, Kasner's is an ominous and profoundly beautiful proof that it surely does exist. Kasner seems to travel there, to compose the beings and forms which have come to birth, and provide a frozen glimpse into this parallel world. Serpentine egrets of longing, disembodied heads of wailing banshees, stoic trojan horses... all hang suspended in a tomb of paint and resin

enveloped by a thick atmospheric fog.

The early collaboration pieces were sketched in a blood-like stain of ink, skeletal forms of Kasner's beings sans flesh. I layered on top of them to give a respectful burial in anticipation of his subsequent exhumation.

The uncanny metamorphosis that plays out via blind collaboration soon became apparent. Tentacled wraiths of sewage spilled from a soul's cage, a field of disembodied death's heads floated in space, a crucified being suffered a strange and unholy stigmatism. These visages could be revealed to me only through a collaboration with the likes of Stephen Kasner.

Side by side or in direct collaboration, our work resonates as sigilistic layers. Anomalous proportions and scyth-like movements of form have come to be unhidden. Their results so far seem to point in the same tenebrous direction... into the muted regions.

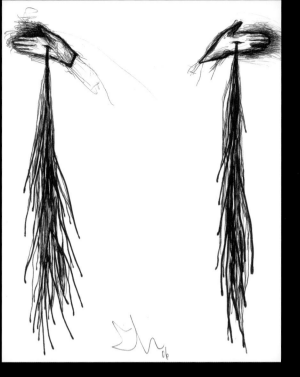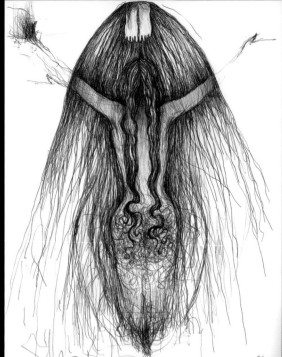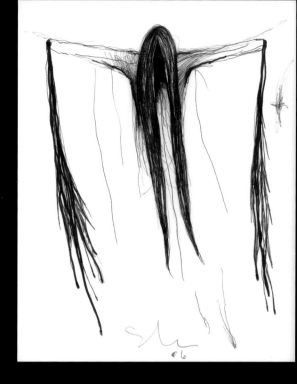

STEPHEN KASNER - SF STUDIES, I, II, III. *Ink on paper, 11 x 8.5″ each* 2006

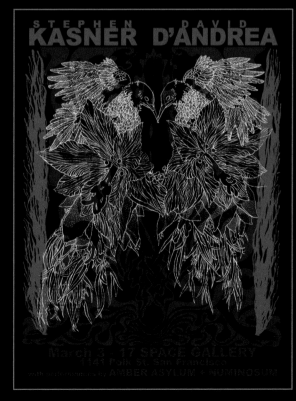

STEPHEN KASNER AND DAVID D'ANDREA - SAN FRANCISCO EXHIBTION COLLABORATION POSTER. *Three color silkscreen, 24 x 18″* 2006

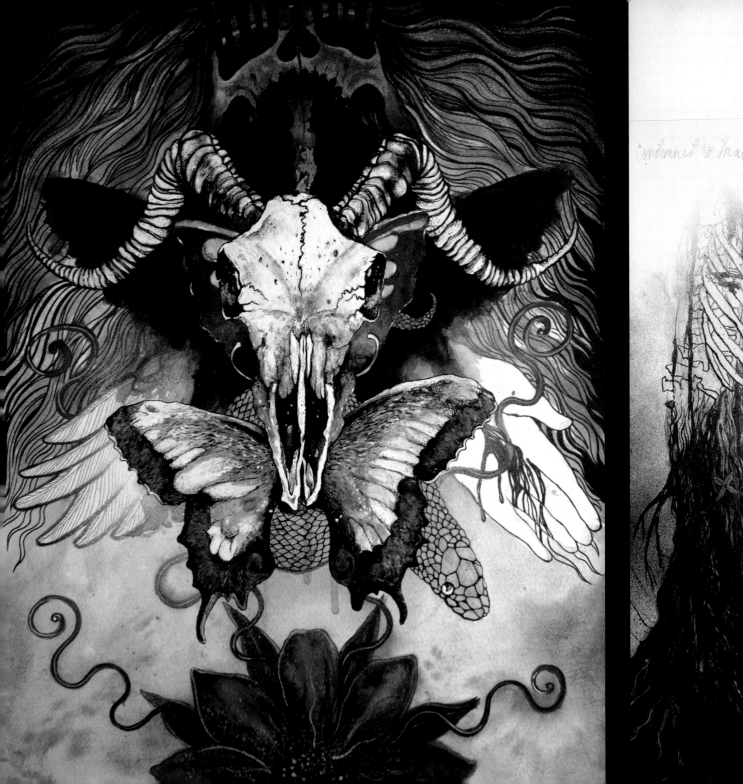

condemned to draw this

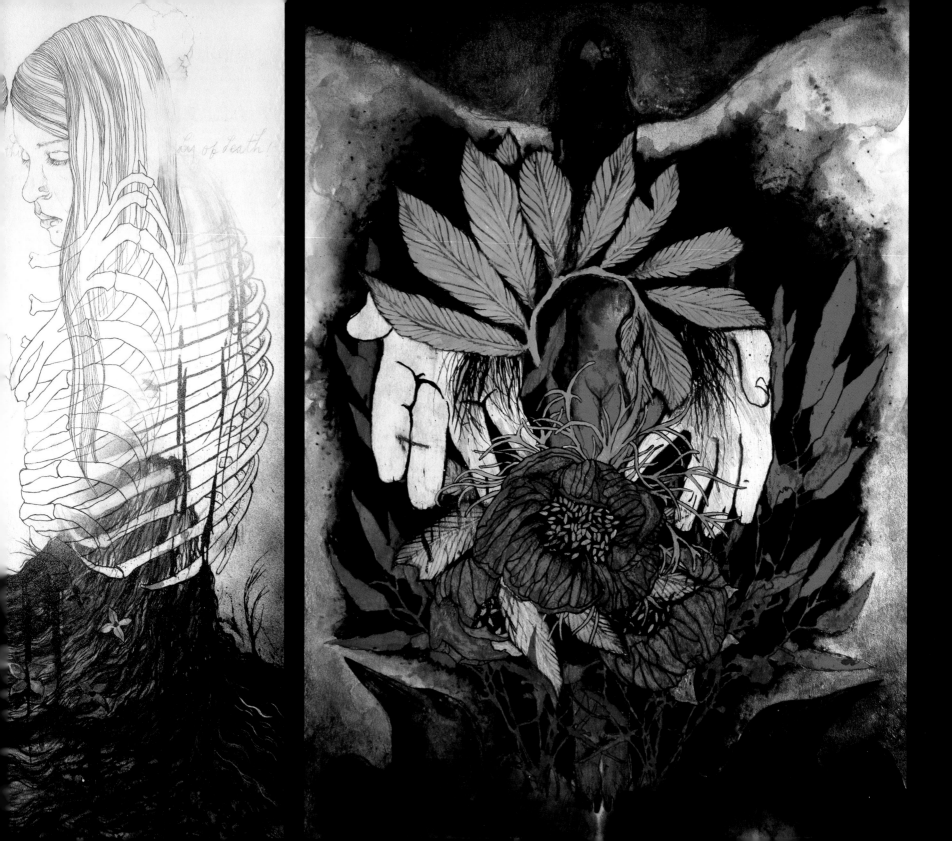

The man was blackened from head to foot, burnt by a thousand suns, distant and dead, mutilated stars groaning in a darkness that flattened the edges of the universe, he had the hands of a murderer, stranglers hands that bore the marks of struggling teeth and burning skin and nightmares of the flesh, hands that tied knots in the night itself, that wringed the life out of the black winds that passed his many homes, always on the edge of the great ravines, in caves hollowed out of time and stone, in recesses of granite and pestilence, hands that lunge in silence pulling the great raven from the sky, his eyeless gaze, burning across the vast broken plains, the remnants of everything turned to dust and the dreams of his ancestors turned to glittering black diamonds, laying scattered like jagged dragon's teeth, hungry for lost souls drifting in the dark on bloodied and battered feet, the ragged wind, forlorn and broken, hiding in places in stillness, in fear of discovery by the ancient gaze from above, stones dulled by the eternal dark keening silence, burrowing into the earth, their muffled cries heard by nothing and no one, a silence so deep the shimmering stars can be heard as they die in agonizing increments of infinity.

In distant nights, on horizons that have yet to be touched by the sun, where the dark is like a bottomless ocean reaching upwards to damnation, where the sightless birds leave tracers of black blood that burn their signature into the sky, symbols of the plague, fine lines that together invoke a fluttering that shatters the silence with thunder and mischief, dark wings that glisten with hate, that wink out hope with each heart beat, tiny eyes that see nothing, beaks savage and small like pencils sharpened to draw blood from the sky, feathers that touch the air, leaving dark shadows of fear, silver scars that draw black blood from poisonous clouds, formed from the volcanoes at the mouth of the great storm, thunder clouds carrying the spawn of the great beast, the whispering nightmares buried within the cumulous shapes, relentless and ravenous ghosts of misfortune, a bottomless

appetite gnawing on the air, discarding the bones of the last drops of rain, stolen from the acolytes of hope, those strange beings that dared to offend, who were sacrificed, anonymous and alone, their screams shattered a million grains of sand and filled the air with enough anguish that the great flock feasted for a 1000 days and nights, until their gorged bodies bled with the souls of the dead.

Silence, the old man moves, so slowly, a statue carved into the dark, his eyeless gaze severing the threads that hold time together, the great flock wheeling above in despair and elation, clouds of sacred feathers, glistening in the darkness, fall about him, stirring the stones such that they retreat into the ground, shadows of the ravens beckon to the stars, who hide behind the luxury of distance, uncertain, a strange foreboding traveling through the impossibility of the great vacuum, the threads that hold the great night together, quiver as the flock gathers, as one great tornado of gnashing bloody beaks and cannibalistic fury, wings and entrails litter a

Seldon Hunt is one of today's foremost graphic designers *and illustrators. The Australian born designer has garnered international recognition for his continuously innovative design methods and his inimitable sense of graphic aesthetic. Hunt was born in 1969 and studied Graphic Design at the prestigious Swinburne School of Design in Australia. Over the past years his poster and cover design work has become internationally recognized and his work has become part of the visual language of the new modern rock genres, post 2000. His work has been exhibited around the globe and he has been featured in numerous publications worldwide.*

SELDON HUNT, 2006
Self-Portrait

landscape blistered by forgotten plagues and wars that consumed entire populations, in hopelessness, and opened the door into the great darkness, where the old man laughs in tune with his patience that has endured aeons without even a thought, as the flock meets the edge of above, and the dead pile high to meet the soundless rage of wings, something stirs from below, something forgotten by even those that made what has been destroyed long before that which has become, this place of destruction and eternal malice.

Great wings beat, beneath the earth, a howling that floods the plains, drowning out all hope, even that which is born of despair, nightmares crease what remains of the sky, shadows crumble into piles of sad precious stones, hollow monuments that reflect a universe filled with the cries of the great swarm, the unholy man on the hill slides a reptilian tongue over lips that have tasted only that which is unspoken, the blood of the ancients burns in his dark veins, the eyeless gaze turns to the heavens and the smile of

truth and knowledge shatters the dark, the last grimace made by that they called Man, is born away on those wings of decay as the great Beast, reveals itself, born at last, at the last moment of time, a shadow that blackens the universe from edge to edge, spilling out into that which is impossible, the great void, a cascade of silence spills into that unknown place, and the stars scream one last time after their birth, they fall in glittering lumps of sand and gas and liquids of poison and fire into the great abyss, silently tumbling through a darkness without end, without meaning, a pinprick a billion light years wide beckons, from below, a darkness that glitters from that great eye that watches with glee, as all that has been, falls in eternal silence, pitiful and broken and forgotten. Forever.

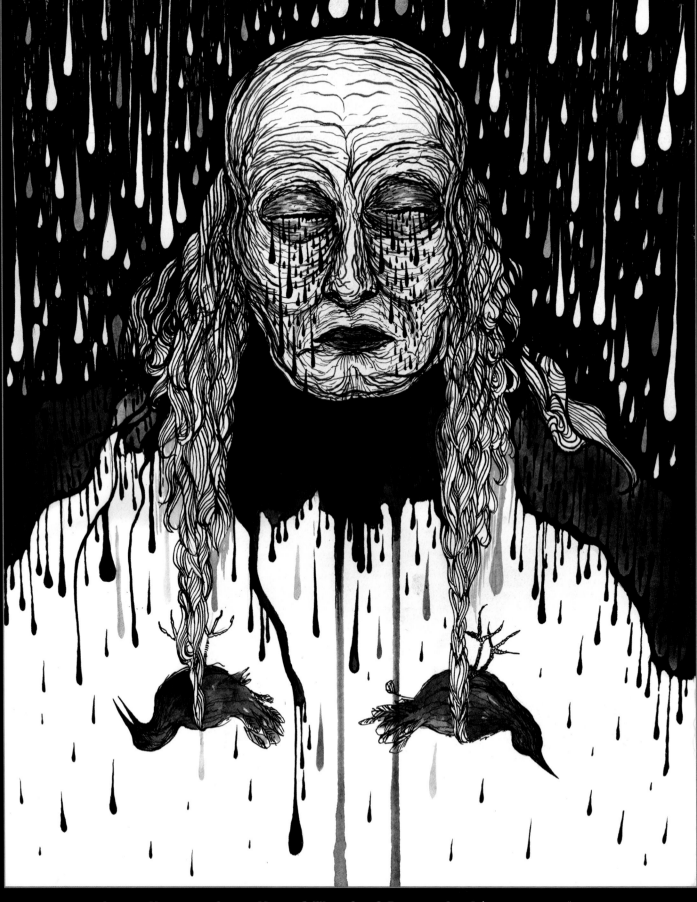

Stephen Kasner and Seldon Hunt - O Weary Sky, O Darkened Sea. *Ink on paper,* 14 x 11″ 2006

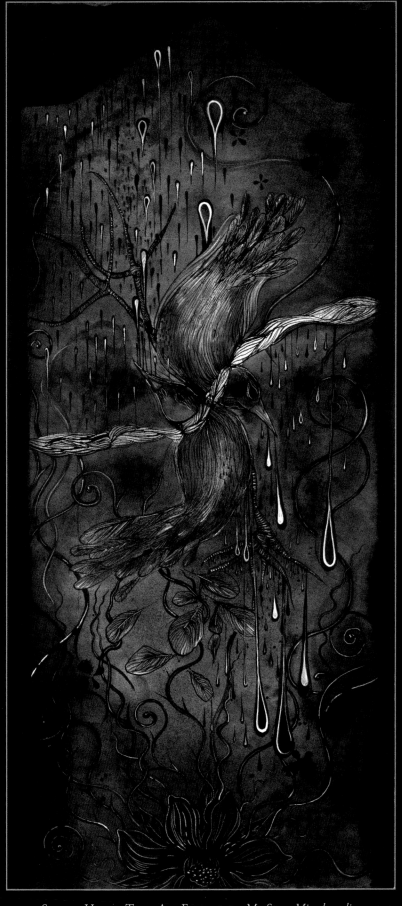

Stephen Kasner and Seldon Hunt - Thou Art Forgotten, My Son. *Mixed media on paper,* 22

KARMA AS ACTIVE INGREDIENT
by Steven Cerio

Karma is an active ingredient, not a mystical construct for robed cultists. Good makes good because it already was - bad makes bad 'cuz it is. A belligerent office boy makes enemies in the office and one of his foes interviews him for a raise. That's karma. Thorn out of the lion's paw. Karma. All of the magic(k) in the world is a possibility and karma is first in a long list of active ingredients that make up cause and effect. No mysterious forces, no poetry. A cause and an effect more powerful than anything we could ever design. It's the same reality that keeps dislocated arms and kisses, not just a thought. No one shares the "thought", we don't even share colors. Describe the color green to me without mentioning an object of that same color. Communication is a VERY big illusion. Where is it on the map of your brain, or America, that you share these delicate emotions or love for particular arrangements of musical notes? Nowhere.

We are self-involving lumps of chemical reactions: mimicking, wanting, needing, loving, and perceiving in as many ways as our brains care to. Remember that your wrinkled, pink mind is an organ run on chemical response, like a stomach or liver, but this organ stores more volatile material; intelligence, stupidity, creativity, pain, and sexual impulse. ALL of that at the end of a nerve - in the compressed time of a chemical reaction that you could never control at will. It's your chemical boss - a chemical reaction that is yours alone. No one in this (or any other) universe of lives or possibilities eats a strawberry just like you, or experiences a strawberry just like you. One man stops to admire a field of roses, the next man turns away, another man sneezes. Where is this shared experience? Is that song good or bad? Is she attractive? There are NO true definitions, just symbols: smiles, frowns, letters, and words. Just symbols and that's all that works. Facial expression, writing, aggression, physical stance, music, and art is all you have. Which one works exactly? That changes from one cluster of two legged cells to the next. That

"collective subconscious" that lonely people wistfully daydream of changes by zip code and varying cable services, literally. When are we? Where are we? How could you know? We are all drunk on our impulses: scratch the elbow, masturbate, eat, or laugh. Tipsy on "my grandma died" or "the poison oak on my finger itches." We are never here, and never in the moment. The *Tibetan Book of the Dead* states, "O Nobly born, let not thy mind be distracted." Easier said than done, eh? You are alone with all of your deafening aesthetics and urges, but you have to be BIG. I believe that's the beauty of it to Stephen Kasner. It's the flower for his hummingbird.

Lecturing on the responsibilities of all artist ee cummings described art as, "...the most awful responsibility on earth. If you can take it, take it - and be. If you can't, cheer up and go about other people's business; and do (or undo) till you drop." Art is the final attempt to convey, to give something away and sometimes, against the odds, it works! What a relief. The seemingly simple but

Steven Cerio is an author, illustrator, gallery artist, poster designer, teacher, and founding member of Noiseville Record's psychedelic combo, "Atlantic Drone." He has been long associated with San Fran's great eyeballed ones, "The Residents," for whom he has created swarms of graphics and animations. Cerio's official site was launched in '96. Steven is currently at work on a series of toys, as well as a new book, and graphic novel, all of which are sure to be of interest to fans of his sugar sparkled psychedelia.

STEVEN CERIO, 2006
Self-Portrait

triumphant occurrence of an idea passing through and taking residence in an opposing brain is as close as any of us can ever get to knowing anything outside of our rarely welcoming and obstinate phenomena.

Kasner is working in a time that has taught multitudes to despise or avoid human touch, find brushstrokes "messy", and accept online/electronic sex and affairs as adequate forms of amorous behavior. The proverbial pushing of the envelope has gone underground with the book readers, jazz musicians and poets. Mankind now prefers to mimic robot perfection, dance to machines, and cut out a germ free and touchless sexual existence. They carve out unquestioned intellectual existences on the web where the only opinions they choose to reference are in full comfortable agreement with their own. Creating freely and effectively in your own voice in this binary age as Stephen Kasner demonstrates, is far more important and dangerous than ever before. Human "imperfection" is an endangered construct

and a ferocious punch to the face of their frozen, in the past, ready for marketing today and consumption tomorrow culture. Countless regurgitations of retro pop culture are speaking to us all in "known" symbols and borrowed iconography. A "known" so common and plain that it is known to the suburban housewives, lazy hipsters, and mass marketers alike. A "known" that is conveyed with stolen personal phenomena and intellectual properties lifted from dusty flea market bins. A regurgitated retrospective offering no more nourishment than the modular hot glue creations of any pedestrian craft show.

And yet Kasner goes on describing his own molecules, records his own story and his phenomena. He takes illumination to task with techniques perfected before the invention of the camera. Are the images lying? Are they telling the truth? The cliff on the down slope of a sugar high overhangs a valley littered with muddied bird fractions and snakes coiled in dust. The temperature... cold. Soot

takes the place of snowflakes and mildewed tornadoes disturb coal dust. Basement light. Hummingbirds tap the honey from stale daisies under bare bulbs. A morose thought gone sour in the crisper. A hole where the pain was. Something born then rusted over. Ash just under the beauty of a curve on the thigh. Logic has no place in these moments. This is about his pleasures.

We all want to feel better. We all need to feel better - this'll do it. That'll do it. Bliss is the fundamental form and necessity. You can't hide. There are no ravens waiting for your soul in here. PLEASURE - yours.

With love,

Steven Cerio
Baldwinsville,NY
September 2006

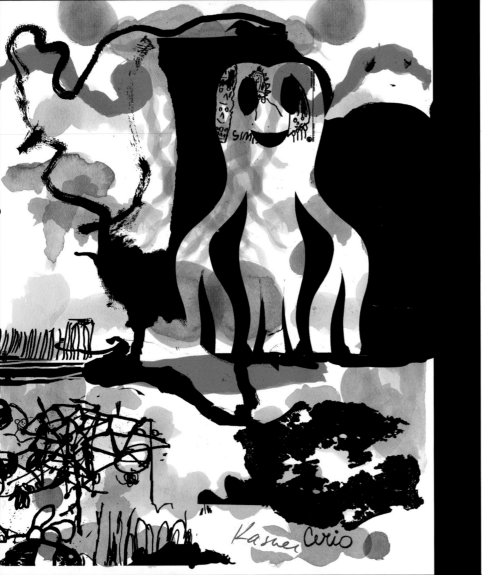

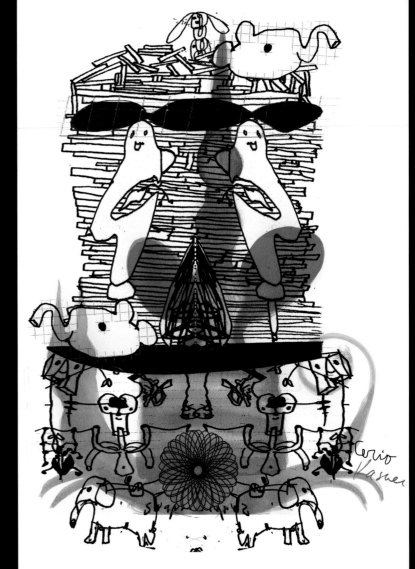

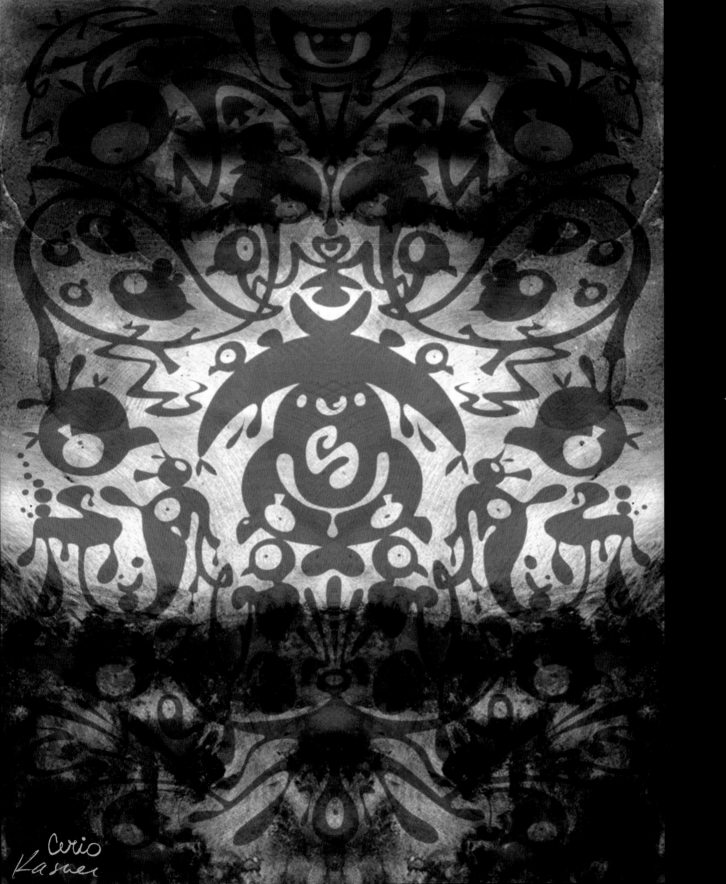

Strychnin Gallery, Berlin, Germany – *WERDEN*
January 19 – February 18, 2007 – Solo exhibition

1300 Gallery, Cleveland, OH – *Stephen Kasner, Douglas Utter and David D'Andrea*
December 8, 2006

Strychnin Gallery, NY – *Arcanum*
October/November 2006 – Group exhibition

Berliner Kunstsalon, Germany
September 28 – October 2, 2006

SPACE Gallery, San Francisco, CA – *Stephen Kasner & David D'Andrea*
March 3 – 17, 2006

ArtSF, San Francisco, CA – *Hell Iz Other People*
October 2005 – Group show

Red Ink Studios, San Francisco, CA – *Labyrinth*
September 2005 – Group show

OnSix Gallery, San Francisco, CA – *Violence*
July 2005 – Group show

BLK/MRKT Gallery, Los Angeles, CA – *Every Other Moment: Stephen Kasner and Charles Sherman*
January 8 – February 26, 2005

Parramatta Heritage Centre, Australia – *Fantastic and Visionary Art*
December 17 – January 30 2005 – Touring group exhibition

Balazo Gallery, San Francisco, CA – *Visions From the Abyss*
October 22 – November 10, 2004 – Group show

Fletcher Gallery, Woodstock, NY – *Explosive Art*
September 16 – October 7, 2004 – Group show

Chamber Gallery, Sacramento, CA – *Madness and Malady: Stephen Kasner and David Ho*
September 11 – September 30, 2004

Ballarat Fine Art Gallery, Australia – *FVA Tour*
July 23 – September 5, 2004

Riddoch Regional Gallery, Australia – *FVA Tour*
April 30 – June 27, 2004

Manning Regional Art Gallery, Australia – *FVA Tour*
March 18 – April 18, 2004

Roq la Rue Gallery, Seattle, WA – *Grave Matters/Fete Noir*
October 10 – October 31, 2003 – Group show

Dabora Gallery, NY – *Mortis Dabora*
October 4 – October 31, 2003 – Group show

Williamsburg Art and Historical Center, NY – *Brave Destiny*
September 20 – November 2, 2003 – Group show

Hawthorne Gallery, Woodstock, NY – *Modern Art Visionary*
September 5 – October 4, 2003 – Group show

1300 Gallery, Cleveland, OH – *Sexhibition*
July 25 – August 7, 2003 – Group show

Global Arts Link Gallery, Australia – *FVA Tour*
June 14 – August 3, 2003

1300 Gallery, Cleveland, OH – *Towering*
September 6 – September 27, 2002 – Group show

Dead Horse Gallery, Cleveland, OH – *Stephen Kasner & Douglas Max Utter, Recent Paintings*
August 30 – September 21, 2002

Orange Regional Gallery, Australia – **FVA Tour*
August 13 – September 14 2003

Agora Theatre, Cleveland, OH – *HessFest*
August 10, 2002 – Group show

Galerie Morpheus, Los Angeles, CA – *Dirgeworks*
June 1 – June 29, 2002 – Group show

1300 Gallery, Cleveland, OH – *50/50*
April 5 – April 30, 2002 – Group show

Orange Regional Gallery, Orange, NSW, Australia – *Visionary Art*
April 13 – May 20, 2001 – Group exhibition

Gallery Nine, Cleveland, OH – *Transitions 2001*
March 31 – April 29, 2001 – Group show

Independent Art Gallery, Cleveland, OH – *flare(s)*
July 21 – August 21, 2000 – Solo exhibition

Society of Illustrators, New York, NY – *42nd Annual Exhibition*
March 18 – April 15, 2000

Sixspace, Chicago, IL – Away
March 10 – April 2, 2000 – *Solo exhibition*

Fawick Gallery, Baldwin-Wallace College, Berea, OH – *Figuresgardensmonuments*
January 19 – February 12, 1999 – Group show

Altered Image Gallery, Lakewood, OH – *Endtime*
February 20 – February 27, 1999

Altered Image Gallery, Lakewood, OH – *Ground of Glass*
March 15 – May 3, 1997 – Solo exhibition

Dark's Art Parlour, Hollywood, CA
December 8 – February 2, 1997 – Group show

Saddleback College Art Gallery, Mission Viejo, CA
October 25 – December 5, 1996 – Group show

Cleveland Independent Art Gallery, Cleveland, OH – *Stephen Kasner & Guy Aitchison*
October 13 – November 4, 1995

IDEA Garage, Cleveland, OH – *Human*
November 5 – 13, 1993 – Group show

select bibliography

Strychnin Gallery – *WERDEN* Exhibition Catalog, 2007

Strychnin Gallery Artist Catalog - Edition 1, 2007/2008 Artist Showcase

Berliner Kunstsalon - 2006 Exhibition Catalog

Parable Visions Magazine - # 3, July 2006 – *The Story So Far*

Art That Kills: A Panoramic Portrait of Aesthetic Terrorism 1984–2001 by George Petros - Creation Books, 2006

Spartan Dog [spartandog.com] - vol. 1, April 2005 - *Cosmic Observations*

Cleveland Free Times – August 2002 - *Into the Shadows*

LINK: A Critical Journal on the Arts in Baltimore and the World - #7, February 2002 - *Visionary, Australian Style* by J.R. Fritsch

Visionary Art: Exhibition Catalog, Orange Museum, NSW, Australia April 2001

Cleveland Free Times - July 26, 2000 - *American Gothic: Stephen Kasner at Independent Art*

Lucifer Rising by Gavin Baddeley - Plexus Publishing, 1999

Obscura (Germany) - vol. 1, 1999 - *Stephen Kasner*

Art Visionary - #2, 1999 - *Ashes From Echoes* by Martin McIntosh

Shortwave Warfare - vol. 3, 1999 - *The Art of Stephen Kasner*

Descent vol. 5 - *Stephen Kasner* by Stephen O'Malley

Unpopular (Sweden) - #1, 1999 - *Stephen Kasner*

Seconds - #47, 1998 - *Stephen Kasner* by Steven Cerio

Hellion - #3, 1998 - *Stephen Kasner*

U.S. Rocker - #3, vol. 8, March 1997 - *Stephen Kasner*

Art? Alternatives - #8 - *Of Morpheus' Realm: Work by Stephen Kasner*

Dark's Art Parlour Magazine - #2, 1995

Funeral Party - New York University Horror Society, 1995 – *Stephen Kasner*

Alternative Press - #68, March 1994

Public Eye / Canada's True News and Picture Paper - March 7, 1994 - *Paintings From Hell*

The Washington Post / Style Section - February 13, 1994

Cleveland Free Times - vol. 2 #7, 1993 - *Art Brut*

aknowledgements

Rebecca Kasner, Madeleine Lila Jain, Chris X, Kevin I. Slaughter, David Beaver, Circle-9, Daniel Koja, David D'Andrea, Steven Johnson Leyba,
Seldon Hunt, Steven Cerio, Douglas Max Utter, Dwid Hellion, Nick Bougas, Kasner Family, James Plotkin, Leslie Barany, David Guido,
Yasha Schulz-Young, Rodney Rose, Andrew Westerhouse, Mills Family, Russell Family, Gary Smalley, Richard Fiorelli, Wille Family,
Peter Gilmore, Ron Kretsch, Karen Novak, John Bomba, Robert C. Stevens, Shawn Bateman, Scott Radke, J.R. Fritsch,
George Petros, Chema Salinas, Ida Slaughter, Clint Billington, Chet and Rachel Scott, LaVey Family,
Martin Grech, SubArachnoid Space, Stephen O'Malley, SUNN O))), Meatjack, Trephine, Craw,
Rick Staton, Martin Geramita, Derek Hess, Jason Byers, Bob Stefko,
Ralph Haussmann, Michael Parks, Bond Family

On the internet:
Steven Leyba - stevenleyba.com
David D'Andrea - dvdandrea.com
Seldon Hunt - seldonhunt.com
Steven Cerio - happyhomeland.com
Stephen Kasner - stephenkasner.com

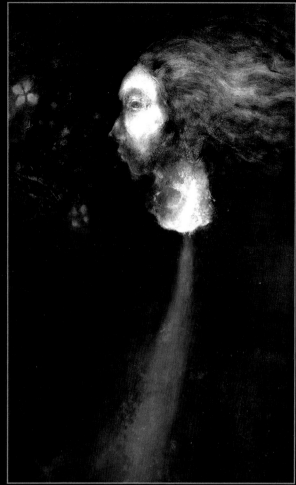

STUDY FOR PALE WOMAN. *Detail*
(work in progress)